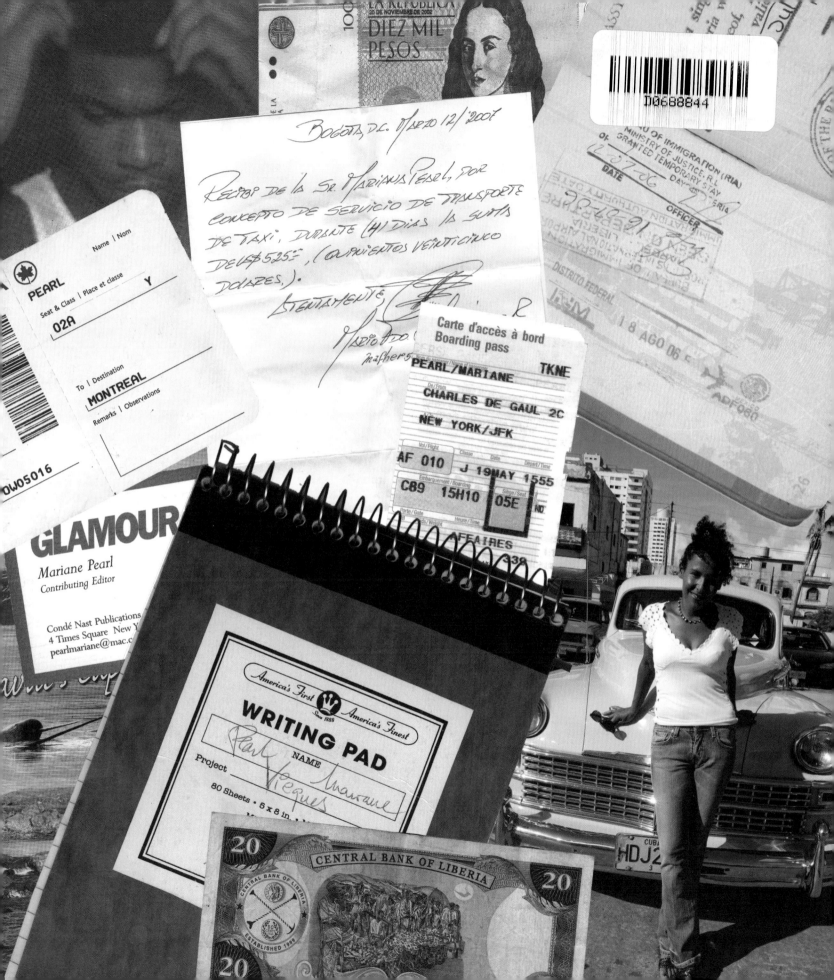

In
Search
of
Hope

In Search

THE GLOBAL DIARIES OF

Foreword by ANGELINA JOLIE

of Hope

MARIANE PEARL

GLAMOUR

 powerHouse Books Brooklyn, NY

To my mother, Marita,
for teaching me that beauty
truly comes from within

Contents

Preface Cindi Leive 9

Foreword Angelina Jolie 11

Introduction Mariane Pearl 13

1 CAMBODIA
 A Sex Slave's Liberation 19

2 CUBA
 Marching for Freedom 35

3 LIBERIA
 Madame President 47

4 MEXICO
 Justice Gets a Voice 61

5 FRANCE
No Longer Invisible 73

6 NEW YORK
A Leader for Lost Children 85

7 HONG KONG
The Conscience of a Country 97

8 CANADA
Hope for a Melting World 109

9 UGANDA
The AIDS Orphan Turned Healer 121

10 MOROCCO
Giving Outcast Moms a Future 135

11 COLOMBIA
A Child of War, Building Peace 149

12 PUERTO RICO
A Woman, an Island, a Triumph 161

Afterword 173
If You Want to Help 174
Acknowledgments 175

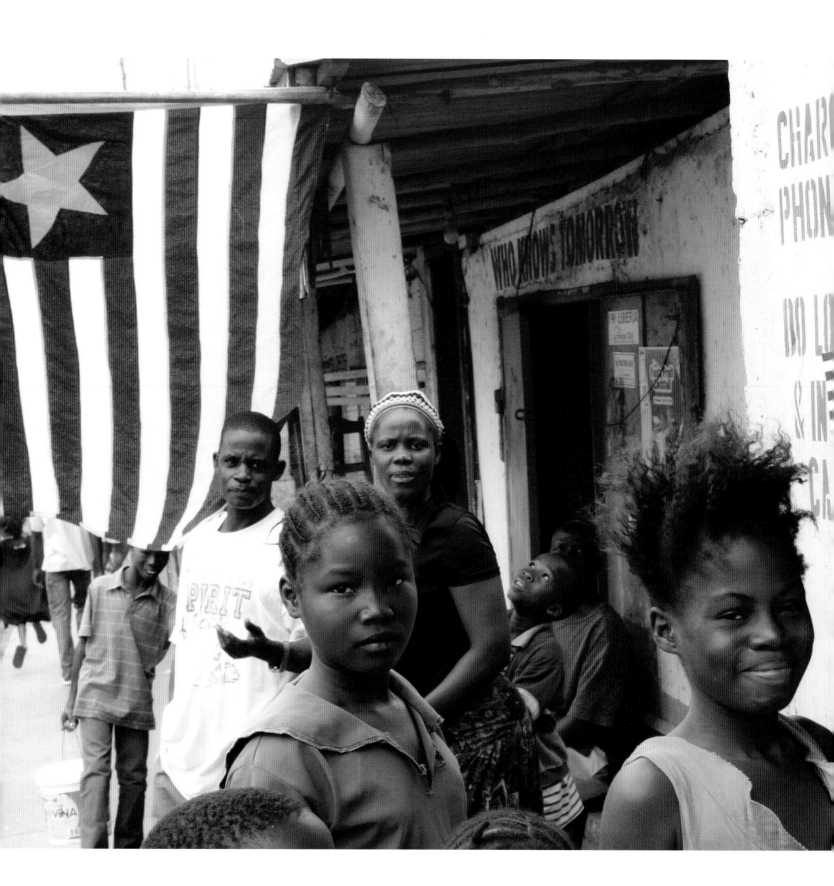

Preface

The book you are holding contains the stories of 13 women—12 profoundly optimistic activists and one extraordinary traveler whose mission it was to meet them.

The round-the-world tour it documents began in the spring of 2006. *Glamour* had been increasing its coverage of global issues, and we felt it was time for a monthly column that would bring home to American women the stories of their peers' struggles overseas. A mutual friend mentioned that Mariane Pearl had been mulling a similar project, a personal search for individuals making a difference around the globe. I was delighted—and awed that a woman who'd been through so much, a single mother raising her young son, would be willing to uproot herself to investigate the world's farthest and often darkest corners.

That intrepid spirit is trademark Mariane—as the millions of women who have followed her columns in *Glamour*'s pages now know. Far from shrinking from the world after the murder of her husband, Mariane has embraced it. The women she profiles here do the same, seeing potential in even the most brutal landscape.

Many people have supported Mariane in her travels. Great thanks go to Angelina Jolie, who portrayed Mariane in the film version of her memoir, *A Mighty Heart*, for her foreword. And *Glamour* is especially grateful to the photographers who accompanied Mariane, illuminating her subjects and providing the rich imagery you see on these pages, much of it previously unpublished.

We are all engaged in a search for hope. This book is an excellent place to start.

—CINDI LEIVE
Editor-in-Chief, *Glamour*

Left: Celebrating Flag Day in Monrovia, Liberia.

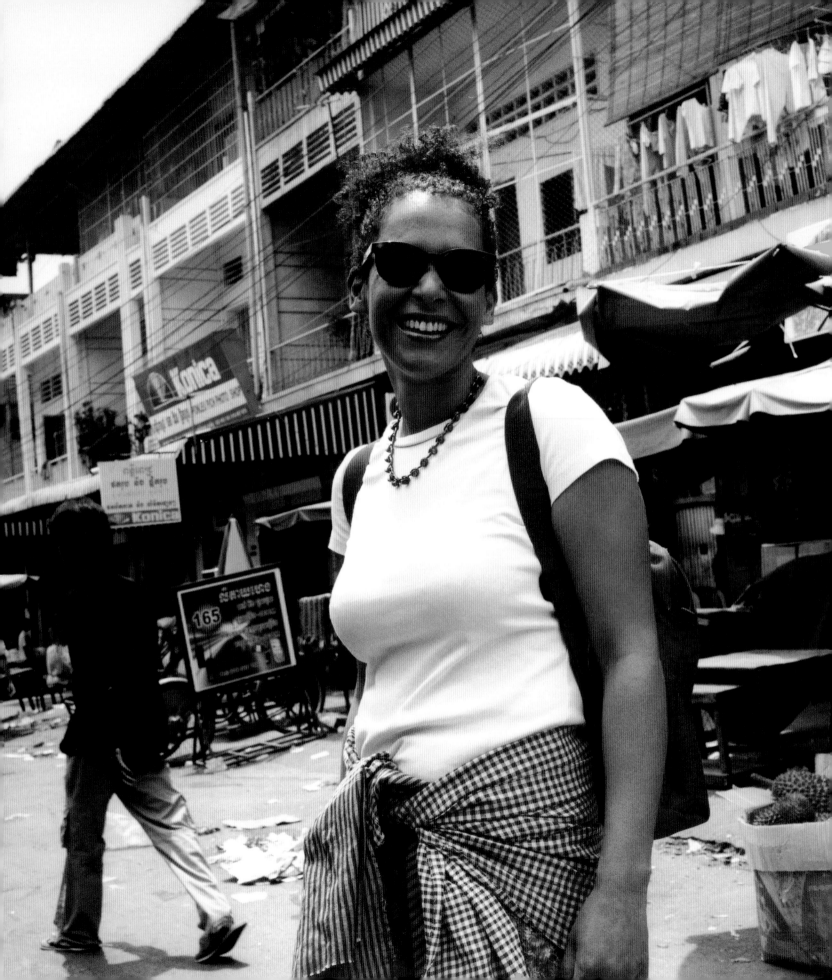

Foreword

Mariane Pearl can recognize strength. A woman of great courage herself, she turns her focus to other women in these essays. Mariane paints a strong picture as she writes. You feel as if you know these women, as if she has invited you to sit beside her and talk with them too. In private moments with Mariane, she speaks of the women as her heroes. They are her sisters in a changing world.

Mariane has taught me not to dwell on problems or focus on the past but to look forward to what can be done. She has been as inspiring to me as these women are to her. And through her, these stories have become a lesson to us all that there is always something to be done; that bravery is not dead; that modern heroes do exist—in the woman down the street or halfway around the world. Her message seems to be that heroes are everywhere, and we should look to them and listen.

There is a saying: "What matters most is how well you walk through the fire." These women, and Mariane herself, have what matters most. When beaten down by life, brutality and hate, they stood up with love, compassion and grace. They lift up and inspire all who are fortunate enough to cross their paths.

I have read and reread these stories and have shared them with friends. I hope you do the same.

—ANGELINA JOLIE

Left: Mariane on the street in Cambodia. Right: With Angelina at Angelina's home in Los Angeles, April 2007.

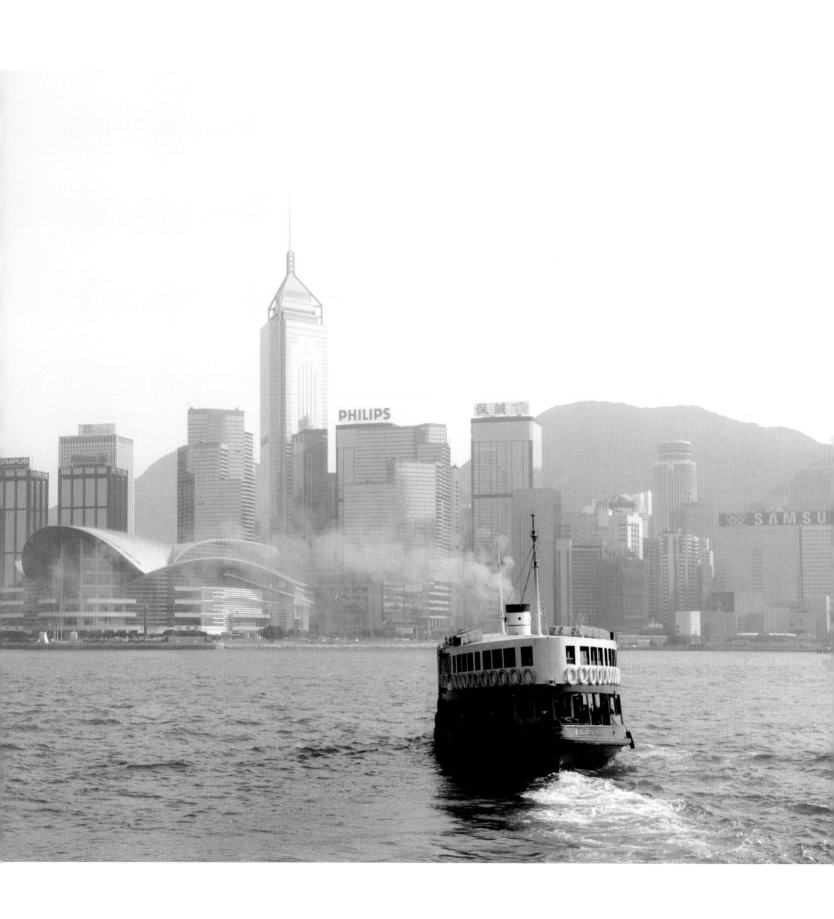

Introduction

MORE THAN A YEAR AGO, I EMBARKED ON a journey around the world—a physical trip with a spiritual motivation. It had to do with the meaning of my life and the meaning of the deaths of those I have loved, but first and foremost, it had to do with my son. How could I inspire my boy, Adam, now five years old, to embrace the world and claim it as his own? It would be legitimate for him to be scared; aren't we all? But was there a way he could genuinely feel hopeful instead?

When confronted with seemingly endless headlines about everything that's going on in the world, most of us take it all in on automatic pilot, struggling to resist the claws of helplessness—that feeling that makes the heart crack open the same way droughts split the thirsty earth. Those cracks in our hearts are where fear settles, distorting our perception of the world and our relationships with others. That fear allows the values that are essential to our integrity—justice and dignity, empathy and pride—to remain hostage to empty rhetoric. But that's not the world. Not necessarily. And the women in this book will prove it.

Left: Hong Kong's Victoria Harbour, one stop on Mariane's journey. Above: Mariane's "travel sneakers."

Personally, I learned the lesson about helplessness the hard way, when my father killed himself. A Dutch idealist, he believed politics could save the world, and so he enthusiastically joined other people's revolutions in Africa, Portugal, Cuba and France. My dad did not take into account that people are people; some thirst for power, others are easily lured into corruption. When politics failed him, disillusion hit him hard. I was nine years old when he passed away. The Cuban revolution had turned into a dictatorship; the French students' rebellion of May 1968 was long forgotten; Africa was soaking in its own blood; and my father was dead. But his last words to me saved my life. It was the conclusion he had reached after a lifetime of searching for the meaning of his own life in the midst of demonstrations and feverish political plans. These words are my heritage, and no money could buy their wisdom: "Don't be cynical," my father told me. "Cynicism is the weapon of the weak."

Then there was my Cuban mother, who taught me how to live. She believed in people, ordinary ones. She had many friends and was expert in matters of the heart. She practically raised all the kids on the Paris block where I grew up, and she had a genuine faith in them. Even though she was a woman left alone with two children far away from her beloved native Cuba, she wasn't helpless. To us children she was a triumphant queen, blessed with the gift of bringing others joy. She passed away in 1999.

A few years later, my husband, Danny Pearl, a reporter for *The Wall Street Journal*, was kidnapped and brutally murdered by religious extremists in Pakistan. I was five months pregnant with our son. Danny's killers claimed that he was a spy working for

the CIA and Mossad, the Israeli intelligence agency, and that because he was a Jew and an American, he deserved death. In reality, Danny was a true citizen of the world who spoke several languages, even some Arabic; he was full of life, smart as hell and funny, too. I adored him. When he died, everything I learned from my parents' lives and deaths came back to me—the politics, the cynicism, my mother's fundamental belief in human nature, the justice, the pride, the dignity. It all came back. And I knew too well the one thing that could defeat me and, by extension, my husband's memory and our son: helplessness. I decided that if those who killed my husband were determined to show the gruesome side of humanity, I would display its integrity, beauty and resilience. That would be my true revenge.

So I embarked on this journey in search of light. It couldn't be a divine light—it had to be human, as I believe only people can undo what people have created. And I chose to focus on women. Why women? With all due respect to the other half of humanity, I have found that women are the most courageous, tough and determined agents of change around—that's just the way it is on every continent. If women were in power everywhere, I believe that the world would be in different shape, even though women (and their

Above: Mariane and her brother, Satchi, in Paris, 1970; Mariane's mother, Marita Van Neyenhoff. Right: Mariane in a Havana, Cuba, market.

Above: Mariane jotting notes in Kampala, Uganda; all bundled up in Iqaluit, Canada. Right: Taking in the Hong Kong sights.

children) are always the most vulnerable victims of hunger, war and disease. Women are the foundation of every family—and every community—and so when a woman stands up to fight for her beliefs, entire families and communities are lifted up. Because the women profiled in this book knew to fight helplessness first, no evil person or deed has been able to stop them. It doesn't matter what others did wrong or how little power they once thought they possessed. They fought doubts and fears, converted anger into indignation and then indignation into action, and in doing so gave birth to a renewed hope. Any woman or man who builds hope never fails to inspire it in others.

The women featured here have championed issues that ultimately affect us all. They are real women who have cried, sweat and bled, each making her own life the raw material from which a role model has arisen. With them, I marched into the brothels of Phnom Penh, where I looked into the eyes of five-year-olds who had been raped and couldn't even blink anymore, their little faces frozen in terror. I saw them find their smiles in the arms of Somaly Mam, the woman who saved them. I saw entire families in Uganda defeated by AIDS staring at the ground, as if wanting to be swallowed by it. But there was Dr. Julian Atim, the young doctor who herself lost both parents to the disease, teaching other AIDS orphans that they, too, could become physicians and save lives. I saw house-wives in Havana whose husbands were rotting in jail simply because they believed freedom isn't a negotia-ble right; those women led dignified protests, resist-ing the fear that has quieted Cuba for almost 50 years. I met Lydia Cacho, the Mexican journalist who has risked her life to unveil a pedophile network involving politicians and businessmen, and Mayerly Sanchez, who at 23 is leading a group of Colombian children seeking to halt years of violence in their country. There are other women featured here—and still others I haven't met yet who I hope will soon join this informal international network of women with faith and guts.

I embarked on this journey with the help of *Glamour* magazine, which has supported my quest and trusted my work. For inspiration along the way, I have turned time and again to a quote from a speech the late Senator Robert Kennedy gave at the University of Cape Town, in South Africa, in 1966:

"Few will have the greatness to bend history; but each of us can work to change a small portion of events, and in the total of all those acts will be written the history of this generation...It is from numberless diverse acts of courage and belief that human history is thus shaped. Each time a man stands up for an ideal, or acts to improve the lot of others, or strikes out against injustice, he sends forth a tiny ripple of hope, and crossing each other from a million different centers of energy and daring, those ripples build a current which can sweep down the mightiest walls of oppression and resistance."

Here are some ripples of hope: real women and their dreams for humanity.

Mariane Pearl

PARIS, FRANCE; AUGUST 2007

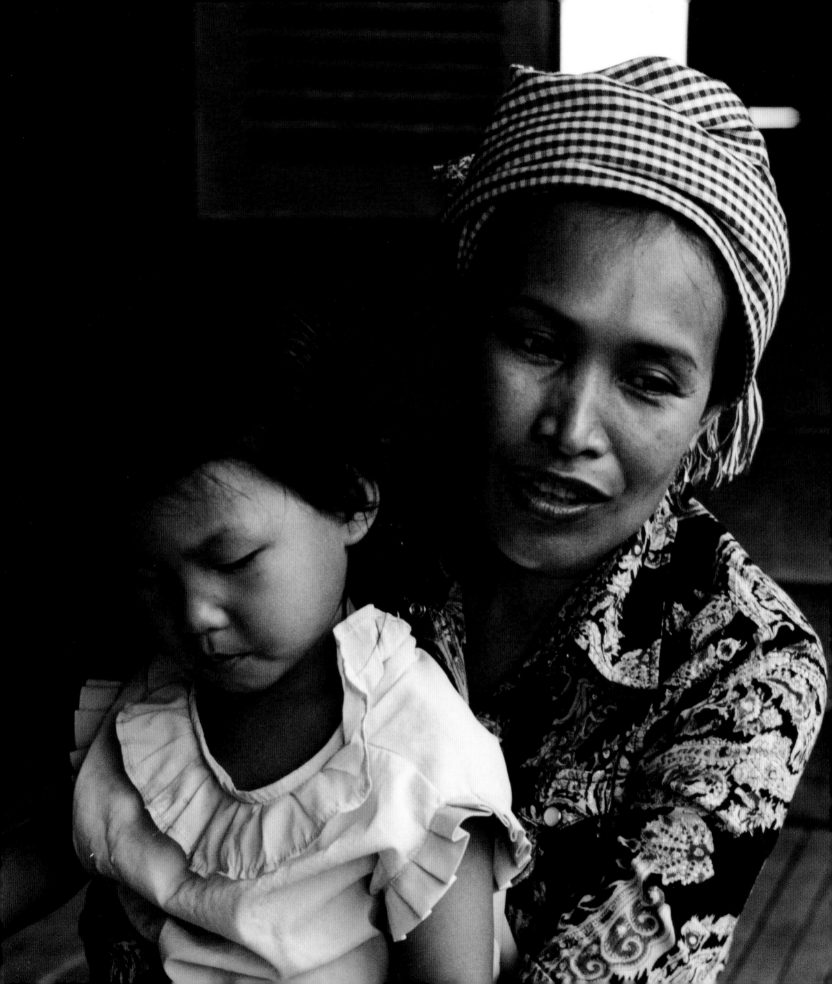

CHAPTER ONE

A Sex Slave's Liberation

SOMALY MAM | CAMBODIA | MAY 2006

IT'S NOON, AND THE HOT SUN IS GLINTING OFF the tin roofs of a rundown neighborhood in Cambodia's capital city. I am standing outside a barrack built of sticks that seems on the verge of collapse, when a door opens to reveal an unlikely young woman. Haggard from a drunken sleep, she is still wearing bright-red lipstick from the night before and carries an odor of sweat, sperm and filth. Her expression is beyond hatred or submission; it's literally otherworldly. This is my first glimpse into the world of sexual slavery in Cambodia.

I peer into the room, a windowless chamber barely big enough to fit a mattress. The dirt floor is covered with cigarette butts, used condoms and Freedent gum wrappers. There is no furniture aside from the bed with its tattered pink coverlet—not even a little box where a girl might hide her treasures. Like many of us, I thought I had an image of what prostitution is. But I knew nothing.

Left: Somaly Mam holds the daughter of a sex worker she helped rescue. Above: Mariane's boarding pass to Phnom Penh.

PHOTOGRAPHS BY JENNIFER MACFARLANE

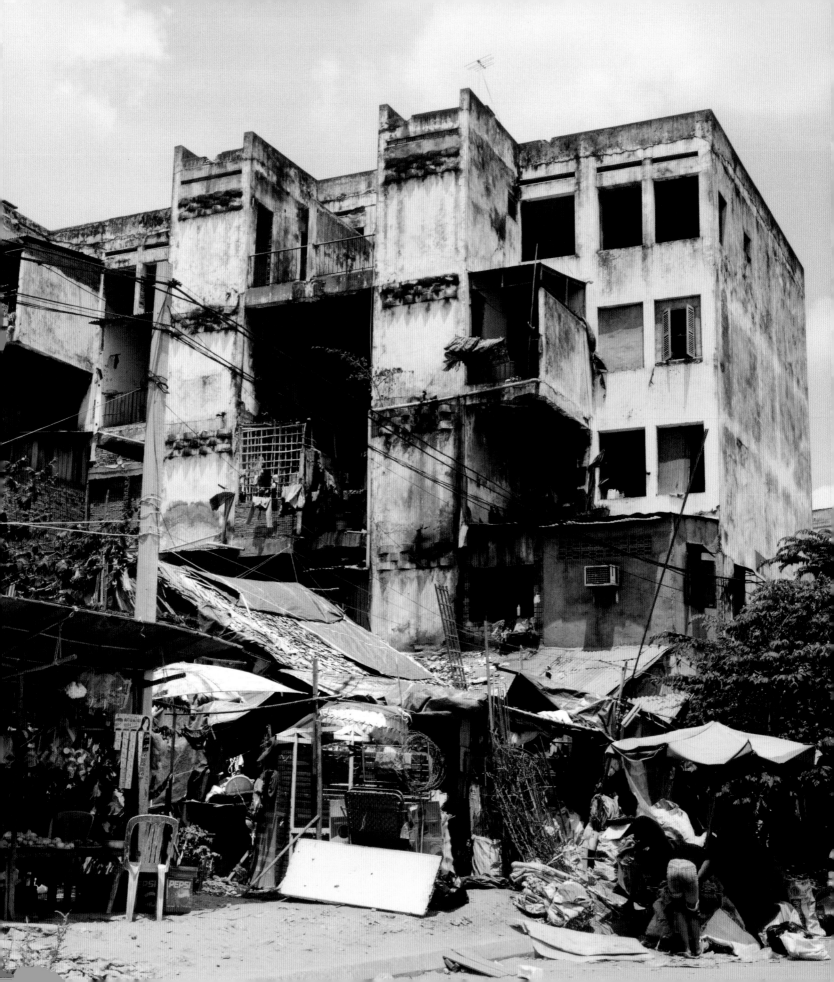

I've traveled to Phnom Penh to meet an extraordinary woman named Somaly Mam, who has made it her personal mission to help girls like this. I first learned about Somaly in 2005, when she won France's Prix Vérité award for her book *The Road to Innocence*. In 2003, I had been given the same honor. By tradition, a previous winner presents the award to the newest one, but Somaly couldn't make the ceremony in Paris, so someone else attended on her behalf. Soon after, I read Somaly's remarkable book and understood why she couldn't be there. She had much more important work to do.

Somaly is on the front lines of one of the most crucial societal battles in Asia and perhaps the world. A former sex worker herself, sold into prostitution as a child, Somaly is the cofounder of an aid organization that rescues young women from brothels and then trains them for jobs that will sustain them in their new lives, such as weaving and hairdressing. Her group, Acting for Women in Distressing Situations, also known as AFESIP (its acronym in French), has 155 social workers in Cambodia and the neighboring countries of Thailand, Laos and Vietnam. Somaly tells me that AFESIP has rescued 3,000 girls since its founding in 1996.

On the first day of my visit, Somaly is in the midst of a crisis so frightening that it nearly knocks the breath out of me. Her 14-year-old daughter, Ning, has been missing for almost 24 hours. Somaly fears the worst: that Ning has been kidnapped—perhaps by a young man the family knows—and is at risk of being sold to a brothel.

As a mother, I know how Somaly feels, frozen by the thought of the terrifying things that could happen to her child. Somaly has learned from experience that tragedies like this are not uncommon here. Girls are regularly abducted, sometimes right off the streets. Such brutality is fallout from decades of war, totalitarianism and genocide. Still deeply damaged from the brutal dictatorship of Pol Pot in the seventies,

Left: The "White Building," where prostitutes gather. Above: A Phnom Penh slum; kidnappers like to snatch their targets here.

"I am not sure what being happy really means," says Somaly. "But when I cuddle with the girls, giving them the love I never received, then I do feel happy."

Somaly plays with some of the kids who are in her center. She has no memories of her own mother.

PHOTOGRAPH BY NORMAN JEAN ROY

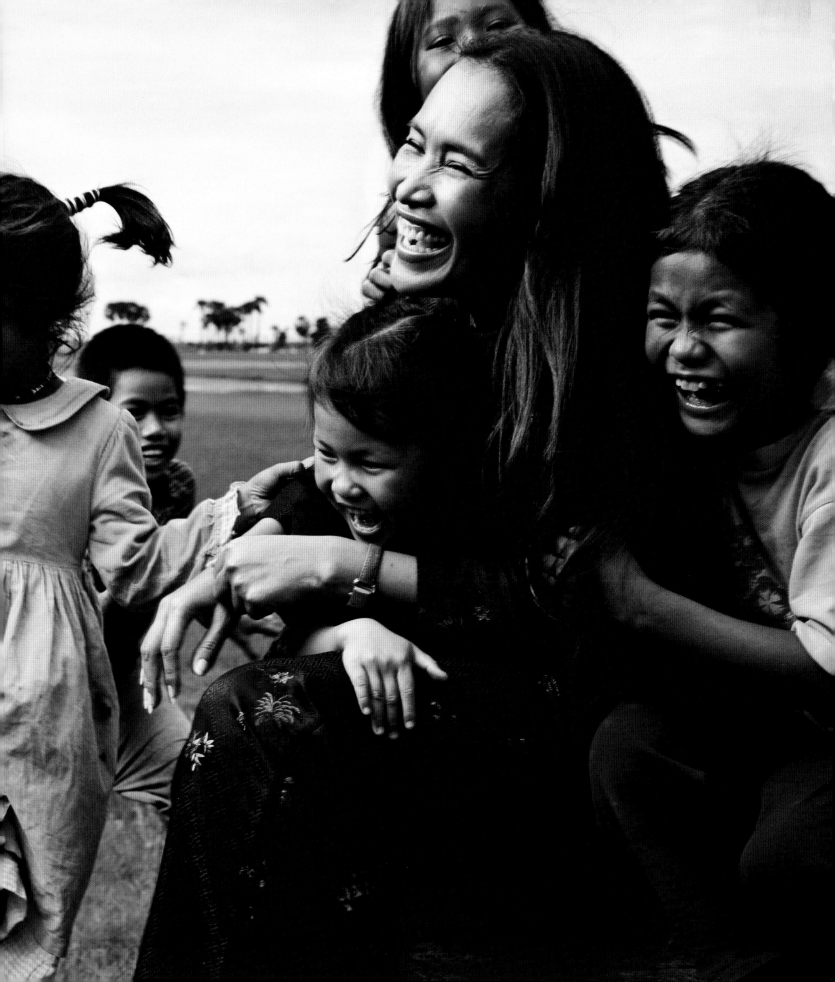

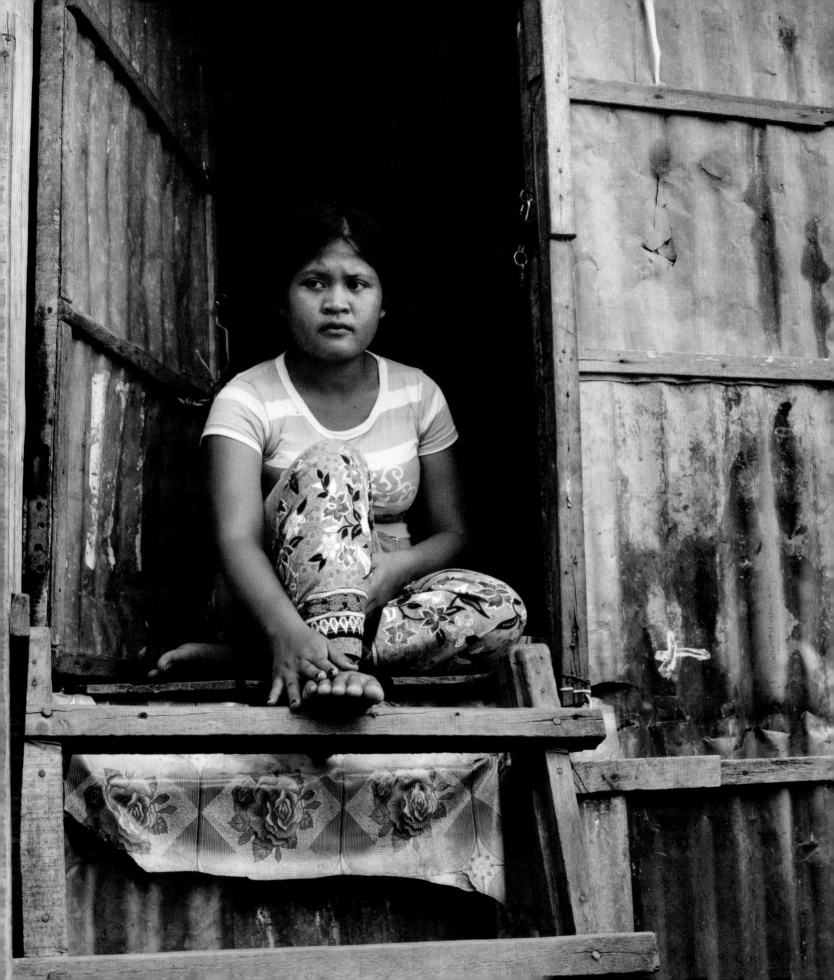

Cambodia ranks as one of Southeast Asia's poorest nations, where a human life isn't worth much. Children here are sold into sexual slavery, sometimes by their own parents, for tiny sums.

As a result, Cambodia has earned a reputation as one of the worst places in the world for human trafficking. The problem is so severe that Cambodia's government established a special office, the Anti-Human Trafficking and Juvenile Protection Department, devoted to the issue. Sereywath Ek, the country's ambassador to the United States, says, "We've made advances," but still the sex trade thrives, fueled by both local men and foreign sex tourists.

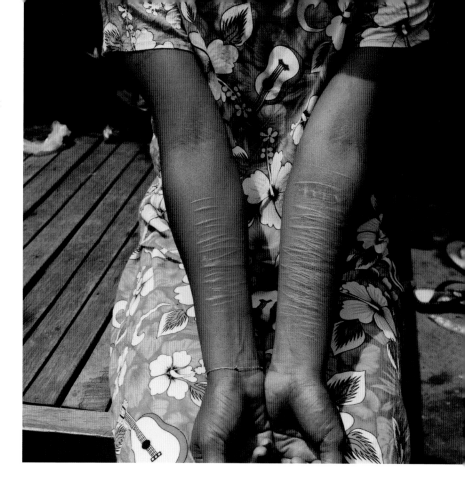

The girls service about 15 clients a night, mostly migrant laborers.

The moment Somaly tells me of the unfolding drama with her daughter, I'm thrown back into 2002, when my husband was taken from me in Pakistan. It gives Somaly and me a strange but undeniable bond that the two of us feel instinctively, and we embrace.

Somaly tells me she is going to meet with the police about the search for her daughter; in the meantime, I set out to learn more about the sordid world in which she fights to work miracles. It turns out to be surprisingly easy. Far from being hidden, Phnom Penh's brothels operate in the open, some right in the heart of the city, even though prostitution is officially illegal. I travel to one of the sex districts with a team of Somaly's social workers, who are allowed into the brothels by the owners because they bring supplies like condoms, soap and toothpaste.

Thus my encounter with the haggard young woman—I learn that her name is Apov and that she's 22—and her sad little room. Afterward, when I step back outside the brothel, I see a girl with a bandage stained with iodine on her head. A social worker, Chantha Chhim, asks what happened. The girl points to a metal stool and answers in Khmer, the national language. "A man hit me for talking badly to him," Chantha translates. The girl also has rows of parallel scars on the inside of her arm. "Amphetamine," says Chantha. When girls get high, she explains, they sometimes engage in self-mutilation.

Left: A young girl waits for work. Above: Another sex worker shows the scars from self-mutilation.

A female pimp reclines nearby in a purple hammock, nonchalantly watching us. As we leave, the girls give us faint, almost apologetic smiles. They service about 15 clients a night, mostly migrant laborers. Men pay the equivalent of a dollar for sex, but most of that money goes into the pimp's pocket. The girls themselves get a salary of about $15 a month, which amounts to mere pennies for each sex act.

The next day,

Somaly tells me she has heard no news of Ning, but adds that the police have made finding her daughter a priority. Somaly's attitude is one of fierce determination despite the circumstances; there are too many lives at stake for her to stop on account of one girl, even if that one is her own. "We have work to do," she insists. "I need you to see how we are helping girls." So we drive outside the city to an AFESIP center that houses 30 former prostitutes. The oldest child there is 16, Somaly tells me, and the youngest is only five.

In the car on the way, Somaly refuses to panic about Ning. Instead we joke around, as if to defy despair. "I don't dislike men," Somaly tells me. "I just can't stand most of them." Her driver smiles. Somaly notices and quickly adds, "He's different," and refers to him as her brother in suffering. Last month, he lost five family members, all in separate car accidents. Suddenly I notice the chaotic traffic swirling around us. A family of five passes us, all riding on a single motorcycle. Bicycle rickshaws weave among buffalo-drawn carts. There is a complete absence of order or logic. Somaly continues joking. "I fired my last driver because he smelled like garlic," she says. But then her tone changes. "I need a mother," she abruptly announces.

Somaly means that literally. She is in her late thirties, but she doesn't know her precise age because she has no information about when or where she was born. Nor does she know her mother. Her earliest memories are of working as a domestic servant for various families in Phnom Penh. Eventually, one of those families sold her to a brothel.

In one day, I've seen the worst of what humans are capable of, and also, through Somaly's love for these kids, what is most beautiful about humanity.

Above: Mariane and Somaly visit children at an AFESIP center. Right: Apov made the equivalent of a few pennies per sex act.

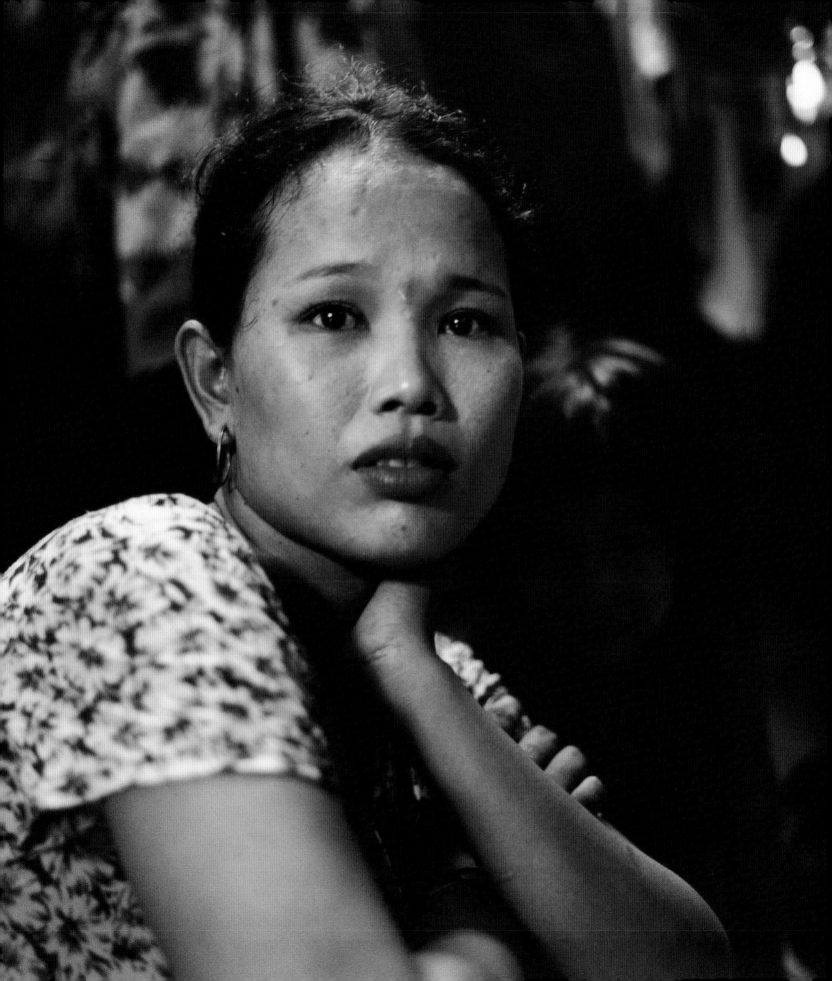

> *Being sold by the woman who gave you life must feel like the most fundamental form of betrayal.*

The defining moment in Somaly's life came, she says, when she saw a pimp kill one of her best friends in the brothel. Somaly says she looked the girl in the eye as she died and realized that she needed not only to escape this life, but also to return and save others. She then left prostitution with the help of an aid worker, attended school and eventually married a French citizen, Pierre Legros, with whom she had three children. Together they founded AFESIP; sadly, they were in the midst of divorcing at the time of my visit. "He is a good-hearted man," Somaly says simply, and then sighs with frustration. Maybe it takes more than a good heart to stay with a woman on such a mission.

When we arrive at the AFESIP center, Somaly introduces me to Pouv, a 15-year-old former prostitute who is in charge of the cooking. Pouv is sitting on the floor, skillfully chopping vegetables. Somaly puts a hand on her shoulder, and for a while the only sound is that of a knife on the wooden cutting board. Pouv begins to tell her story, in a low, broken voice. Somaly translates: "She says she was sold by her mother when she was seven. She gripped her mother's ankles and begged her not to leave her with strangers." The price for Pouv: the equivalent of $10.

Somaly continues the tale. First Pouv was "fattened up and given treatments to whiten her skin," a common beauty practice in Asia. Then she was sold to a man who chained her to a bed and raped her until she fainted. Angry, he returned her to the brothel, where she was punished by being held in a chicken cage; the pimps put chili peppers in her vagina and beat her. "She finally broke," Somaly says. "For the next three years, she had up to 30 clients a day."

Somaly tells me that her social workers rescued Pouv when she was 10. (The workers, as they make their rounds, keep a constant eye out for very young prostitutes like Pouv. Later they may return and, in collaboration with the police, rush into a brothel and snatch the girls.) While we talk, Pouv stares at her feet. I can't help but think about my own young son and the way he trusts me with his entire life. At the very core of Pouv's existence is what must feel like the most fundamental form of betrayal—being sold by the woman who gave you life.

Next I meet six-year-old Mou, whose skin is waxen with fear; she has a fever. Somaly says that Mou was sold by her family to a man who used her as a sex slave. After consulting a psychic, he decided that she brought bad luck, so he kept her in a cage. We also meet a new arrival, a girl of about 12. Never have I seen someone who has so clearly been tortured. Her eyes are wide with terror. Somaly gently asks, "How are you holding up?" The girl tries to answer, but what comes out is something like a distant whistle or a creaking door.

Right: Mou, a former sex slave, lies ill with fever at Somaly's compound.

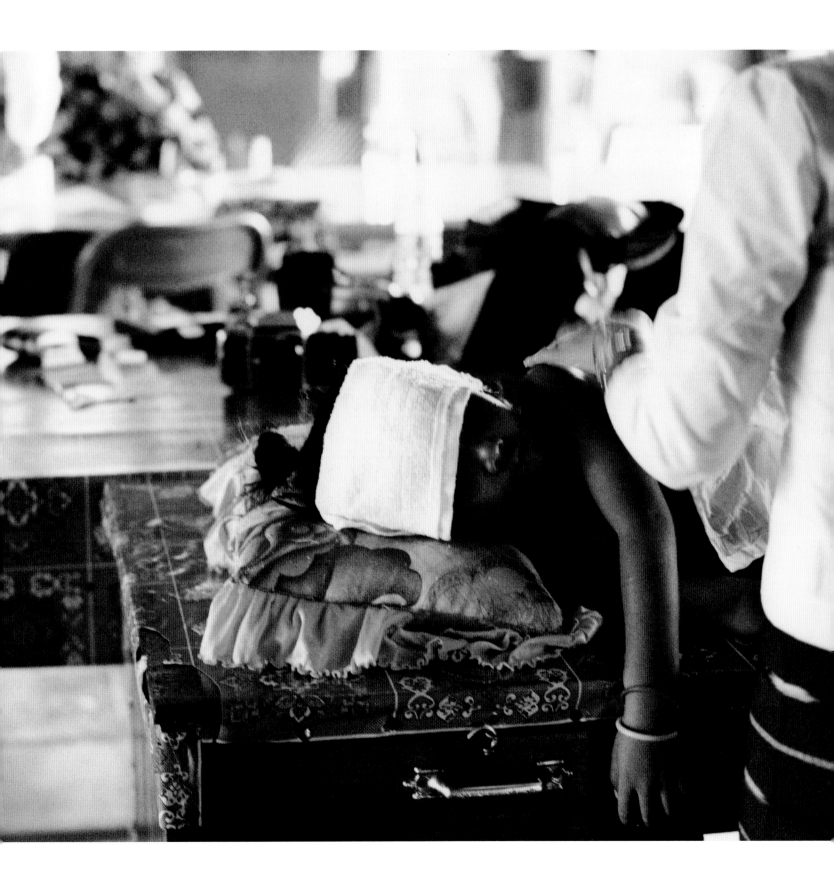

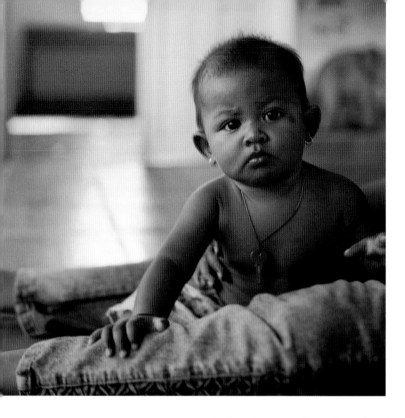

In the afternoon heat, Somaly takes a nap with the children, lying on the floor and embracing each of them; in turn, they hang on to their newfound mother, who had willingly walked back into hell and brought them out. In this one day I feel as if I've seen the worst of what humans are capable of, and also, through Somaly's love for these kids, what is most beautiful about humanity; the wave of pain I'm feeling makes me cry. At that moment, one of the littlest girls wraps her arms around me.

Later, as we prepare to leave, kids come pouring out of a nearby school. A dozen girls in navy skirts and white blouses gather around Somaly like butterflies. They, too, are rescued children, who are learning to read and write. A few of them press into Somaly's hand folded pieces of paper. "Those are their most hidden secrets," Somaly says. The notes tell of wounds that have been buried so deep, they are not suited for spoken words. Somaly understands their pain. "Part of me hasn't healed and never will," she confides. But I can see how the girls give her hope. There is no telling how many girls she will inspire—and how many of them will rescue their sisters and ultimately change the fate of the next generation.

On the drive back to the city, Somaly gets a call from the police. They've tracked Ning to Battambang, a province near the border of Thailand that Somaly says is a notorious human trafficking center. This is good news, because many girls disappear without a trace. Somaly says she must go there immediately. "Keep visiting the girls," she urges. "Please."

That night I head out with the social workers to learn about another harsh reality of Cambodia's sex trade—HIV. An estimated 29 percent of sex workers here have the

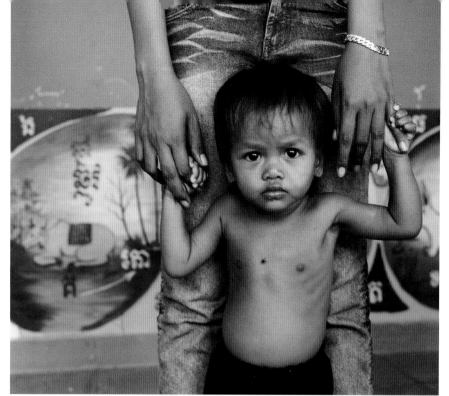

disease. We drive to one of the city's sex spots, known as the White Building because it is mainly a squalid white apartment house where prostitutes gather. When we arrive, we see girls not much older than 14 seated out front on colorful plastic chairs, waiting for clients.

The street is lively in unexpected ways. There are vendors in stalls selling mangoes and kebabs, and naked infants are laughing and playing. Yet the atmosphere feels dangerous. Men on motorcycles circle the street—it's unclear whether they are pimps or prospective clients, but either way they're a discomforting presence. Adding to the bizarre tableau, a skinny man who I assume must be a pimp approaches a girl in a pleated skirt; he slaps her, and she gives him a single bill.

In a nearby building, Chantha, the social worker, is teaching HIV prevention. She has forgotten to bring her wooden penis model, so she uses a pencil instead. The condom hangs ridiculously on the tiny pretend phallus, but no one laughs. Too many of the girls have lost friends to HIV, and they are trying to pay close attention to information that might keep them safe.

The following day, a social worker calls me to say that Somaly has been reunited with her daughter. The police found Ning, who had apparently been drugged, in a bar in Battambang. The good news of her rescue is undercut by bad news; Ning said she had been raped by her three captors—the young man whom the family knows, along with two others.

When I see mother and daughter again, both are deeply shaken. "I think they kidnapped Ning in retaliation for my work," Somaly tells me. I see that this is another defining moment in her life. She is deeply hurt, and so is her beloved girl. But pausing in her work is not an option. She must keep going—for the sake of all the girls she is helping.

Left and above: Children of rescued sex workers in Phnom Penh.

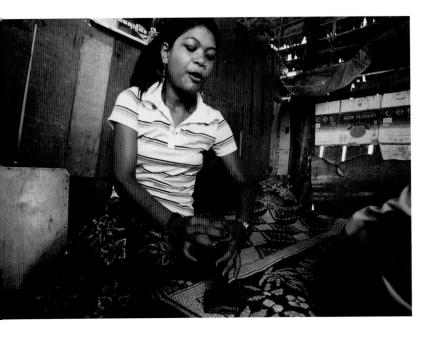

For the sake of her daughter. She tells me how, earlier, she took Ning's beautiful, sad face in her hands. "You've suffered what you've suffered," she told her. "Now you take that pain and you help others."

When I leave that evening, Somaly smiles at me. The gentle expression on her face, the spark in her eyes, are small victories against a backdrop of despair and human cruelty. I think back to something she told me at the beginning of my visit. "I am not sure what being happy really means," she said. "But when I cuddle with the girls, giving them the love I never received, then I do feel happy."

I know instantly what she means—often life's most genuinely happy moments are just holding on to the people we love, still and quiet, no words necessary.

Postscript, August 2007:

After my *Glamour* column about Somaly was published, people from all over the world wanted to join her in rescuing girls from sex slavery. To her surprise, some even showed up on her doorstep in Cambodia. "Every week I've been visited by someone who wants to help out," she says. Many more sent money, hoping their donations could help save a young life. Last October, when Somaly was honored in New York City as a *Glamour* Woman of the Year, I watched in amazement as first the entertainer Queen Latifah and then the legendary TV journalist Barbara Walters each pledged $150,000 to assist Somaly's work. In all, Somaly has received nearly $500,000. She rescued 74 more young women and girls in the six months since the column ran, and the new donations will allow her to exponentially increase her efforts. Somaly also launched a new foundation to help victims younger than 16, providing them education, job training and medicine to treat STDs. (Virtually all have contracted such a disease, including HIV.)

Along with the work she's doing at home, Somaly has been traveling the globe educating people about sex slavery; so far, she's been invited to speak in France, Spain, Italy, Austria, Washington, D.C., and the United Nations in New York. If the world would only listen to Somaly, I know we could put an end, once and for all, to the tragedy of human trafficking.

Above: Sex worker Mao, 18, practices HIV prevention with a condom and a wooden penis. Right: After school, girls rush to greet Somaly.

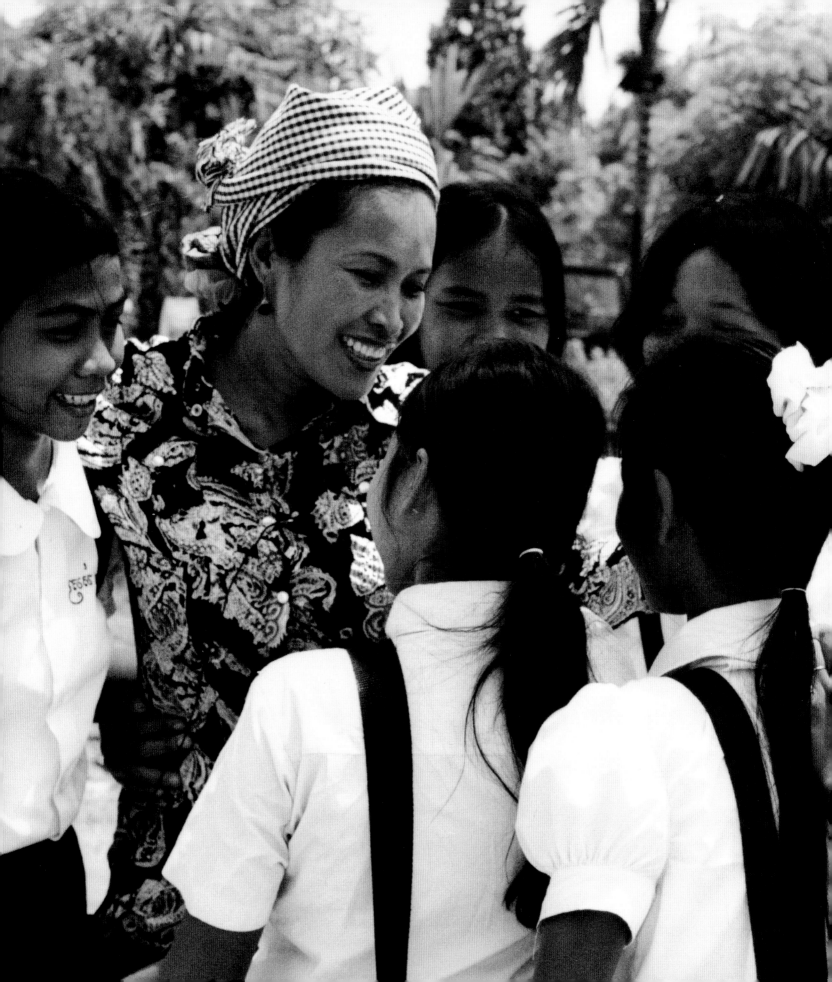

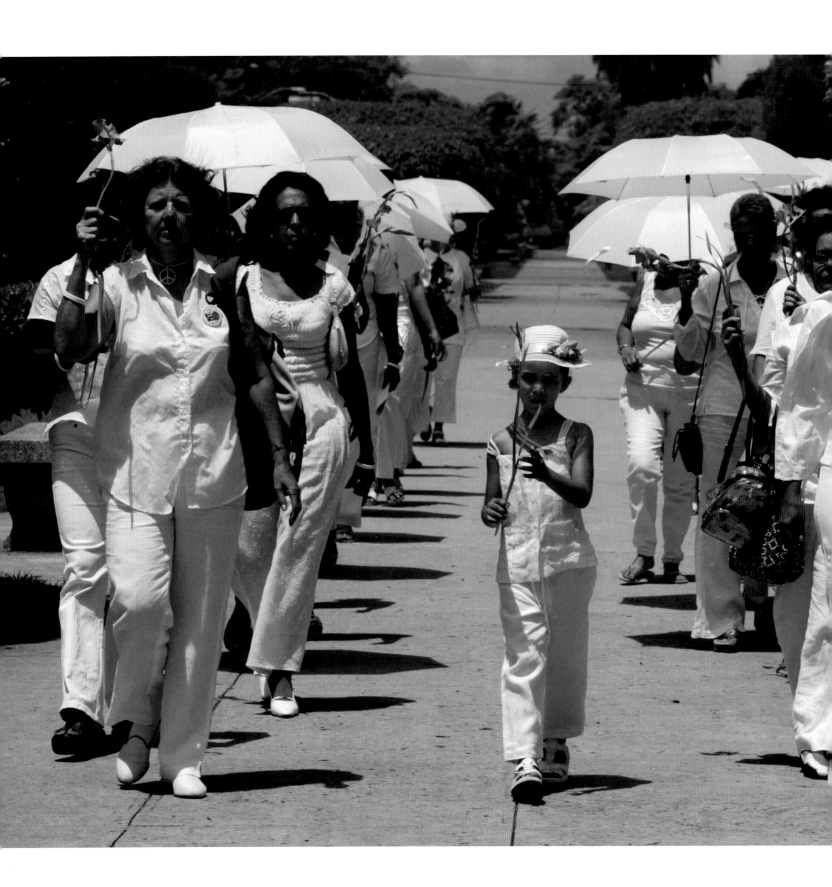

CHAPTER TWO

Marching for Freedom

THE LADIES IN WHITE | CUBA | JUNE 2006

ON A BRIGHT SUNDAY MORNING IN HAVANA,

I watch as more than a dozen women dressed in white, each carrying a pink gladiolus, march along Fifth Avenue, an elegant street lined with neatly trimmed shrubbery and pastel-painted mansions. This is a highly unusual occurrence in communist Cuba: a political protest, albeit a quiet one. There are no slogans to be heard, no signs to be read. The women say nothing, but their silence contains a significant cry for freedom.

They are known as Las Damas en Blanco—the Ladies in White— wives, mothers, sisters and daughters of 75 political prisoners jailed in 2003 by Fidel Castro. The women are marching to demand the release of these men from prison. You could say they are staring down a dictator. It's a poignant snapshot of a Cuba closing in on a half-century of life under communist rule.

Left: The silent march of the Ladies in White. Above: A Cuban cigar box cover from Mariane's personal collection.

PHOTOGRAPHS BY JORGE REY/GETTY IMAGES

35

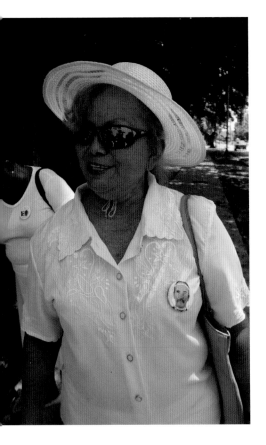

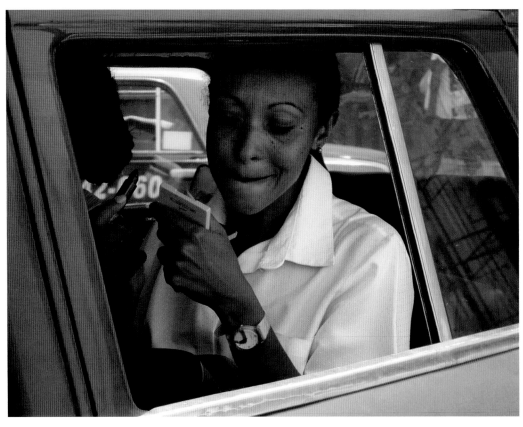

"We might be ordinary women, but we have unshakable beliefs," says Laura Pollan.

Above left: Laura Pollan, whose husband was sentenced to 20 years. Above right and opposite: Colorful cars, relics of another era. (Note: This woman is not a Lady in White.)

Coming here from the brothels of Cambodia, where young girls are sold into sex slavery, I know I'm walking into a much different story about abuse—a story about political oppression that hits close to home. I have been visiting Cuba since I was a child; my mother was born on the island, and although she left in 1965, I still have family here. My emotional connection to the place remains very strong, and there is much here that I love—the spicy, fragrant food; the spirited music that turns everyone into a dancer; the genuine warmth of the people, so welcoming and friendly even in hardship, quick to offer a drink and share a joke, as if there were no tomorrows to worry about.

But every Cuban family, including mine, knows what it's like to have its fate and future controlled by one man. Since Castro came to power, Cubans have grown used to waiting for things—waiting in line to collect rationed food, waiting to be reunited with loved ones who fled an oppressive regime, waiting for the embargo imposed by the United States to end. Waiting for history to turn this seemingly endless page and move on. In this atmosphere, the Ladies in White represent the rarest of breeds—Cubans who have found a way to get the word out: "Enough waiting. Let our men come home." It is a cry from the heart that I recognize all too well.

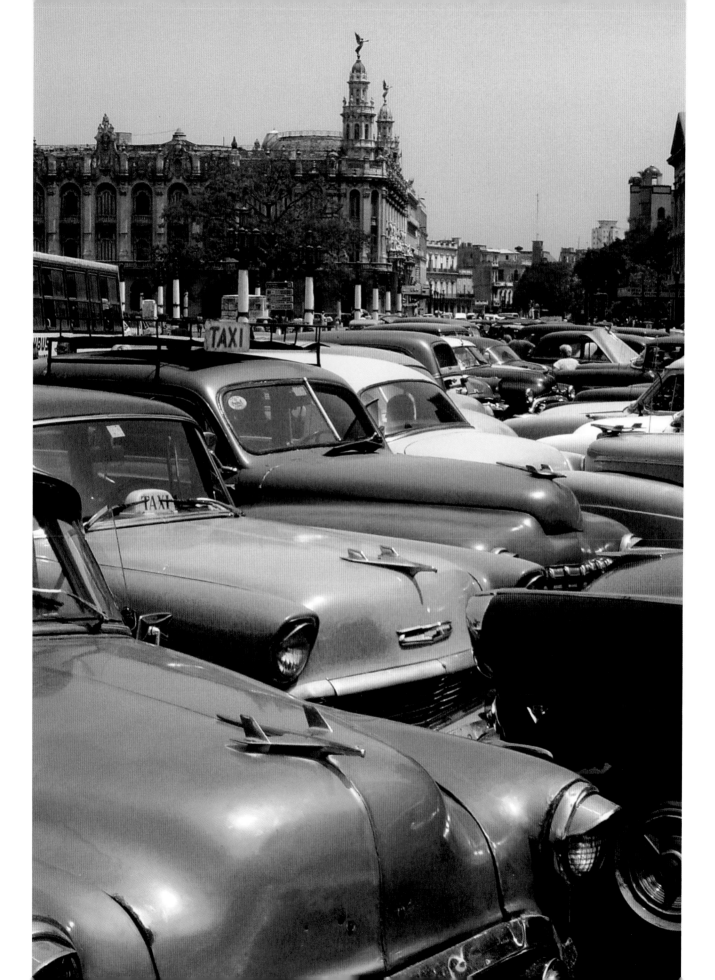

According to their families, the men these women hope to free are prisoners of conscience, arrested for being peaceful activists for democracy and human rights. The government, however, claims that the men are dissidents whose actions undermined the Cuban regime; some have been sentenced to serve up to 28 years in prison.

Since 2003, the Ladies have marched for their men almost every Sunday after Mass at the church of Saint Rita, the Roman Catholic patron saint of lost causes. Their gatherings have come to embody the frustration of a people longing for freedom.

After watching the women march, I go to meet Laura Pollan, 54, a Lady in White who is a teacher of Spanish literature, at her home, which has become the group's informal headquarters. On my way, I see Dodges and Chryslers from the sixties, their paint sun-bleached to a faint yellow, and I pass billboards bearing slogans like "The Nation or Death" and "Capitalists, You Don't Scare Us."

> *There are no slogans to be heard, no signs to be read. The women say nothing, but their silence contains a significant cry for freedom.*

When I arrive, Laura is sitting on a rocking chair in her living room, sweating profusely. Her electric fan isn't working, and she has to rely on neighbors for water since her own plumbing is broken. Her front door is wide open to the busy street. Cars constantly blow their horns, trying to avoid young men on Chinese-made bicycles. Across the way, a band starts rehearsing a song celebrating the joys of lovemaking. Children play soccer on the street corner, while women wearing tight shorts stroll by, calling out to one another.

Laura tells me how her husband, Hector, a journalist, ended up in jail. First he resigned from the Communist Party—a highly symbolic gesture. Then he became involved in groups demanding freedom of speech and the right to vote. As a result, the government labeled him "ideologically unfit," Laura says. One afternoon in 2003, she came home to find that the police had ransacked her house. "They scattered all our papers on the floors, emptied the drawers and even searched the plants," she says. As the police led Hector away that day, he told her, "Do not be ashamed. I am

Right: The Ladies in White gather outside the church of Saint Rita, patron saint of lost causes.

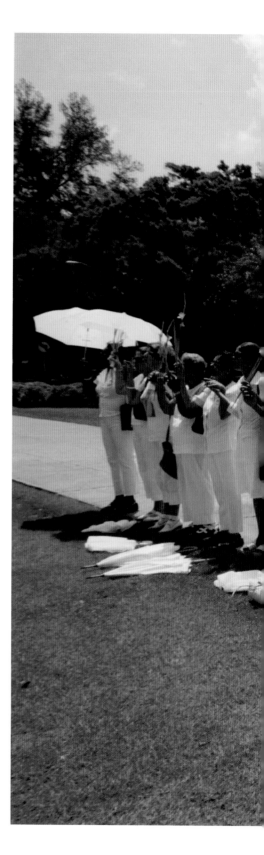

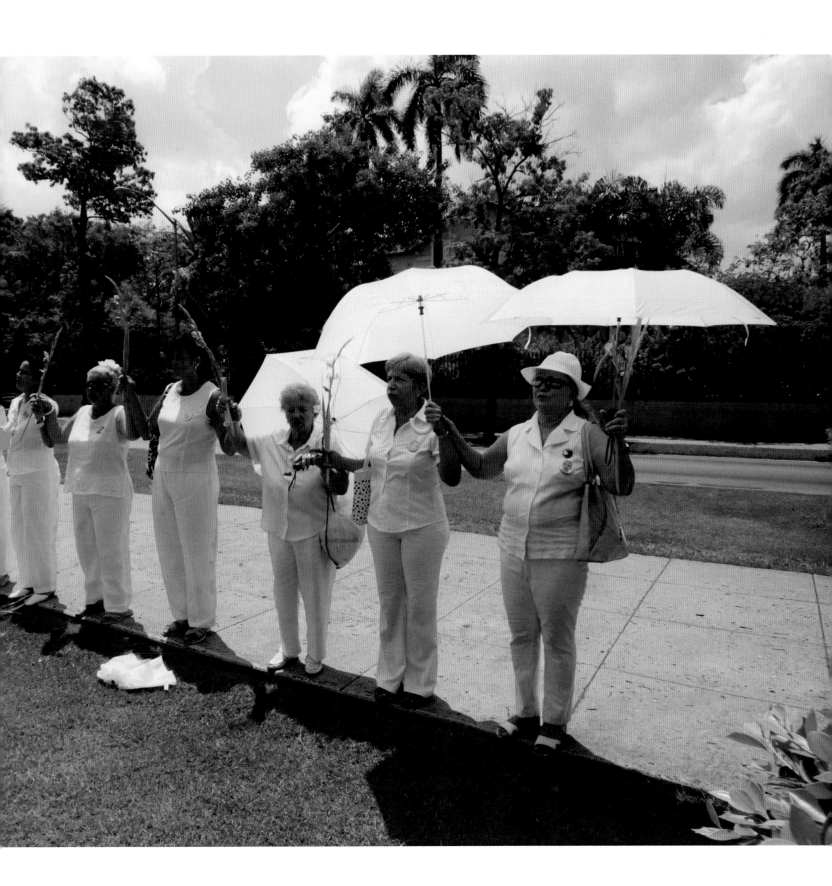

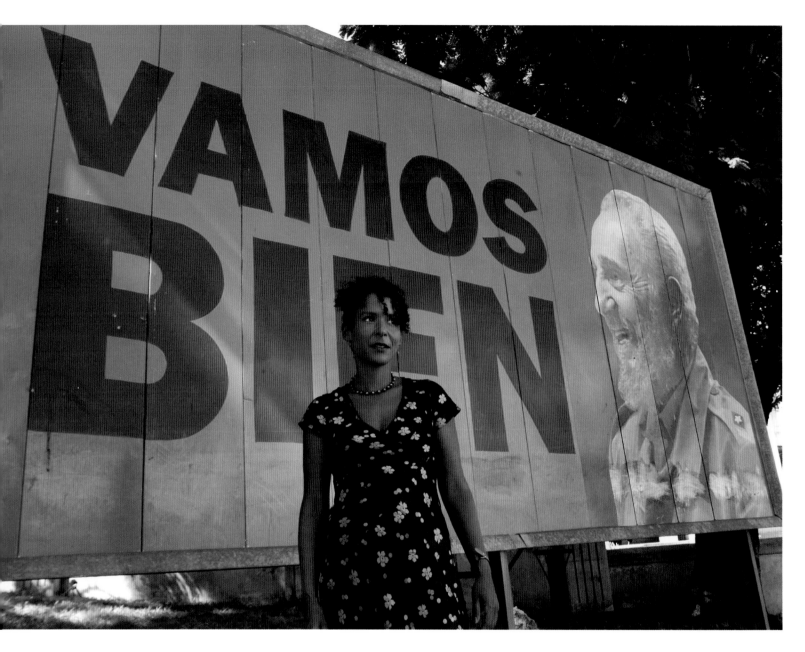

Every Cuban family, including mine, knows what it's like to have its fate and future controlled by one man.

not a thief. I have never hurt anyone. I am being arrested for my ideas." The government accused him of helping terrorists plan attacks against Cuba, and he was sentenced to 20 years in jail, Laura tells me. "In fact," she adds, "the only weapons they ever found were paper and a typewriter from 1958."

When Hector and the other men were arrested, in what has come to be known as "Black Spring," their

women started exchanging letters of support. A child sent a poem to her father: "Daddy, I want you to read me a story and kiss me good night. You are looking awful in this horrible jail. Come back soon I miss you daddy." She signed it "the little lady in white." Soon, dozens of the women began marching. However, over time, the protesters' numbers have sometimes dwindled, Laura tells me, due to the pressure from the police, who sometimes surround the women's houses on Sundays and prevent them from going out.

Laura's story is interrupted when a man holding little conical paper bags stops at her open door. "Here's the peanut man," he shouts in a singsong voice. "Peanuuuts!" Laura smiles at this simple evidence of "normal" life and turns to me. "We might be ordinary women," she says, "but we have unshakable beliefs." She pauses and then adds, "Listen, if there should be only one Lady in White left, that will be me." Laura has spent her life as anything but a dissident; she's one of so many thousands of women who supported the Communist regime change by force or by choice. But this isn't about politics; it's a matter of justice. She has been betrayed.

I also meet one of the younger members of the movement, Katia Martin, a 25-year-old mother of identical twin girls. As we sit in a tiny public park ringed by giant royal palm trees, she tells me about her husband, Ricardo, and his ordeal in jail. "The stress is killing us both," Katia says. "Ricardo's health is deteriorating quickly. He has lost his voice because of a cyst on his vocal cords, and he gets no medical attention. The food in prison is terrible, and the hygiene is the worst." Katia, like the other women, is allowed to visit her husband only twice a month. It is unclear when or if he will be released.

Left: Mariane next to a Castro billboard in Havana; "We're doing well," proclaims the sign. Above: A poster from her personal collection.

Yet despite the many hurdles for the Ladies in White, their message has been heard. In December 2005 they received an award from the European Parliament, the Sakharov Prize for Freedom of Thought, named after Soviet scientist and human rights activist Andrei Sakharov. The women were not allowed to travel overseas to receive the honor, but it helped keep them going.

"I am confident we will free our men eventually," says Lidia Valdes, a 67-year-old housewife who talks

with me one afternoon at her home. Her husband of 40 years, Arnaldo, an economist and writer, was sentenced to 18 years. Lidia feels empowered by the group's solidarity, she says. Through them, "I have come to trust humanity again."

I am moved by the women's peaceful struggle and their colossal but quiet determination. In a country where the leader is fabled for his endless speeches, their eloquent silence has carried enormous power. I can't help but think of my own late

Above and right: Cubans at play. When it comes to human rights, the next generation faces an uncertain future.

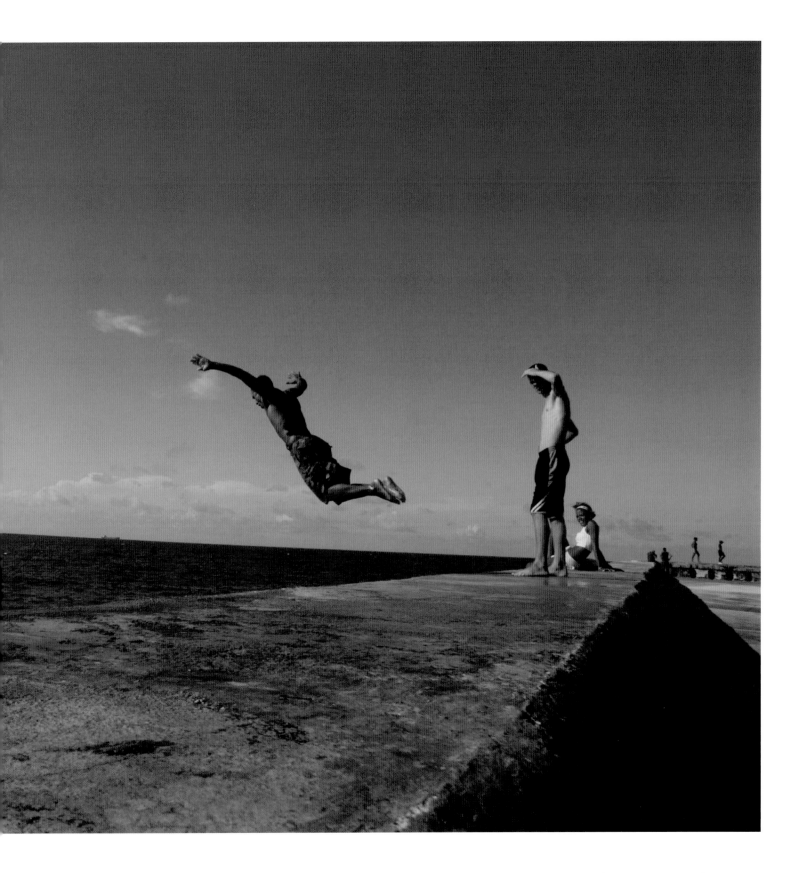

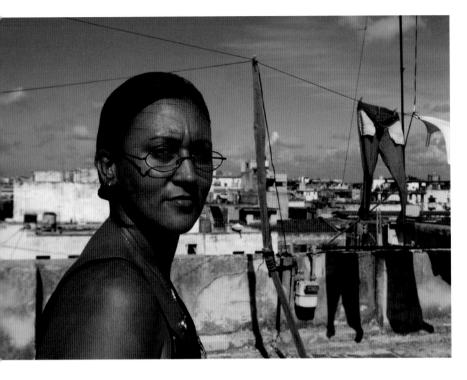

mother, a poor, proud and strong woman, so imbued with the spirit of this beautiful place. I imagine her marching along with these women, holding in the frustration born of this forced silence. As for me, I don't know if I could master such self-control and keep silent each Sunday; I would probably end up in jail. My mom was lucky she could leave Cuba and move to Europe when she married my dad, a Dutch man, in 1965. After that, most residents were barred from traveling freely. But my mother could never truly leave her beloved island behind; my child-

These fathers and husbands, in the dark of their cells, have never been alone.

hood in Paris was colored with her stories of the faraway island, long held hostage to ideology.

My mother waited for the rest of her life for the Cuban people to enjoy freedom; when she died in 1999, that dream had still not come true. I remember once in my childhood, when one of Cuba's periodic mass exoduses occurred, my mother sat in front of our television and sobbed for hours. Entire families were fleeing the island on makeshift rafts, some built out of house doors tied to truck wheels. We watched as our people became little dots in the ocean, fading from sight. Some would make it; some would drown or starve, or be set upon by sharks. I learned then, at 14, how easy it is to take freedom for granted, while so many others have to risk their lives for it.

I can't imagine a more lonely feeling than being imprisoned for your ideals, on an island. What better metaphor for isolation? But these jailed fathers, husbands, sons and brothers, even in the darkest corners of their cells, have never been alone. They've taken courage from their Ladies in White, who march because freedom is a quest that knows no compromise. I'm always reminded, when in Cuba, of a favorite quote from Robert Green Ingersoll, a nineteenth-century American orator: "What light is to the eyes, what air is to the lungs, what love is to the heart, liberty is to the soul of man."

Above: Katia Martin can visit her jailed husband only twice a month. Opposite: Mariane in Havana, where her relatives still live.

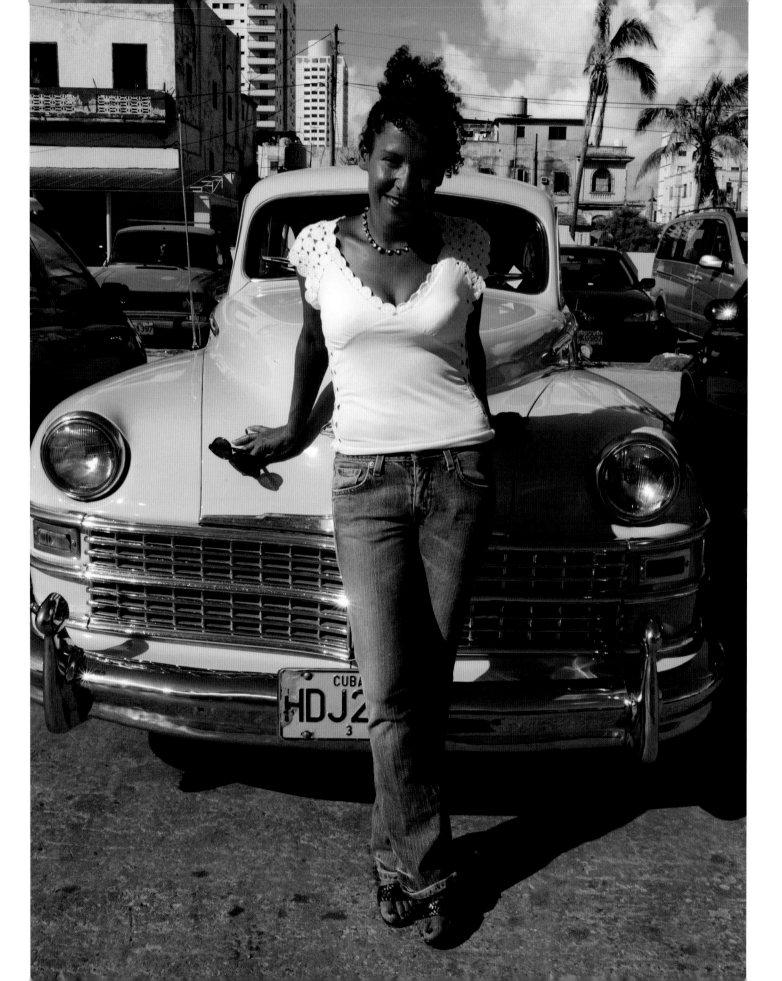

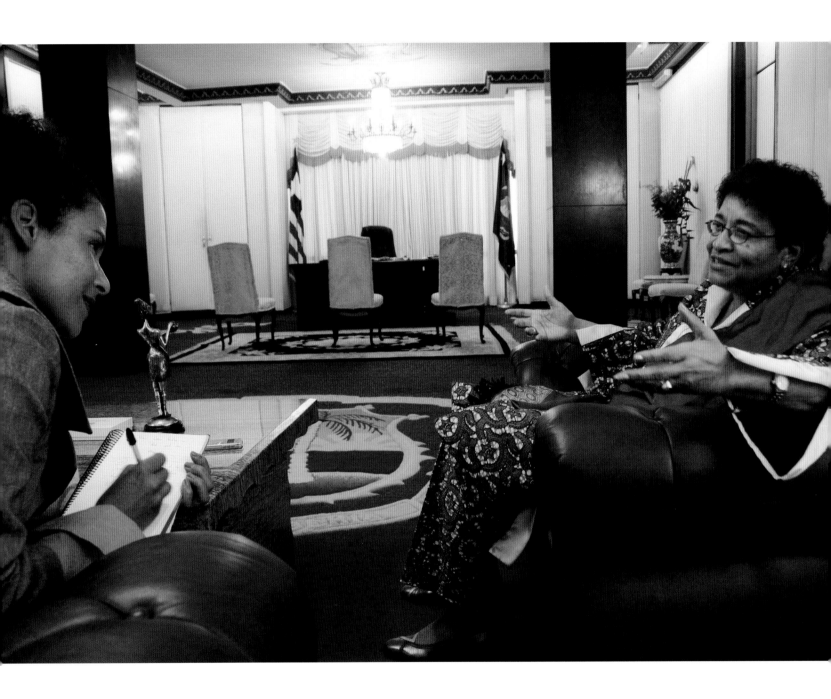

Above: Mariane with "Iron Lady" Ellen Johnson Sirleaf at the Liberian Presidential Palace. Right: The author's Liberian visa.

CHAPTER THREE
Madame President

ELLEN JOHNSON SIRLEAF | LIBERIA | JULY 2006

LIKE ANY PLACE KNOWN MOSTLY FOR ITS

turmoil and little else, Liberia was both familiar and foreign to me as I planned my visit to that country. I had read so much about its civil war over the years, but I had never visited and didn't know anyone who had—it was almost as if you *couldn't* visit. Now, as my plane prepares to land in the capital, Monrovia, this tiny West African nation is finally about to become real for me. But…is it really there? I search for the familiar comfort of city lights at night, but Monrovia is wrapped in darkness. The entire country has had almost no electricity for more than a decade—just one example of the damage done by civil war. My jetliner begins its descent, and through the windows there is nothing to see until we near the runway, which has been lit with the aid of a power generator.

PHOTOGRAPHS
BY SARA TERRY/
POLARIS

47

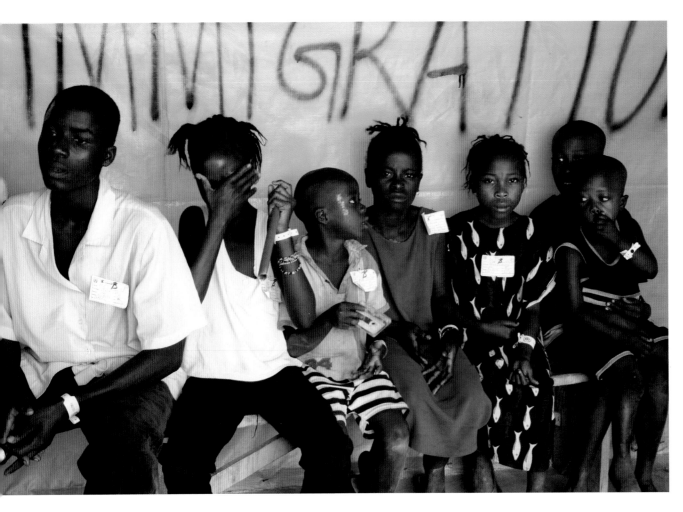

Liberia is waking from its nightmare, and the landscape is devastating.

I feel so blessed to have come to Monrovia to meet Ellen Johnson Sirleaf, the president of Liberia and the first woman ever to be elected head of an African country. At 68, an age at which most people have retired, she is attempting the daunting task of raising a country from its ashes. Unlike Cuba, where the streets have been relatively peaceful despite decades of political repression, Liberia was stripped bare by warlords who raped, murdered and terrorized its people during 14 years of brutal civil war. More than a million civilians died or fled the country; even children were recruited for combat. A cease-fire was finally brokered in 2003, and in late 2005 the United Nations helped supervise a democratic election. President Johnson Sirleaf took office in January 2006.

Liberia, which was founded by freed slaves from America in 1847, is now waking up from its nightmare, and the landscape is devastating. Eighty percent of the population is unemployed, corruption is rampant, and there is no running water;

Above: Refugees await processing before they can return home. Right: Statues of Liberian leaders from times of war—and of Johnson Sirleaf, who represents peace.

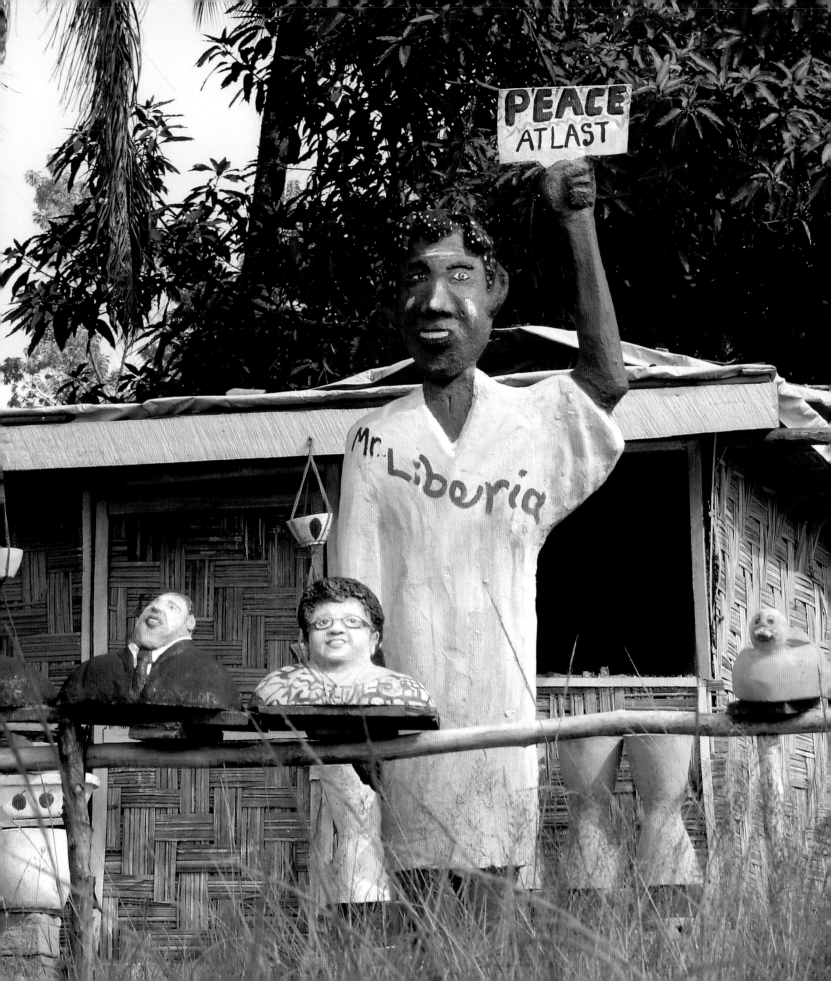

> *Hundreds of vendors sell items that I struggle to identify, like chicken feet and live snails.*

only a handful of buildings even have generators. The United Nations keeps 15,000 soldiers here on a peacekeeping mission.

I have two days to explore the city before meeting the president. On the streets, many people look sad and tired, and there are few opportunities to escape the grim reality—no obvious bookstores or theaters or anyplace to go after dark, except for a few beer bars lit by dim oil lamps.

In the sprawling shopping district known as the Red-Light Market, I see hundreds of vendors offering items that I struggle to identify, like red palm oil, chicken feet and live snails, but there are very few buyers. I meet a serene woman named Femata Morris, who explains why she voted for the president. "She is not interested in wars. She wants to put our children to school," she says. Then she quickly adds, pointing to the fabrics she's selling, "Now you stop talking and buy something from me."

Schools in Monrovia have recently reopened after years of suspension due to war. I stop by a public school and meet the principal, Sarah Barclay. "Many of the children are depressed or hungry or both," she tells me. She introduces me to two girls, Charlotte, 11, and Senebu, 12. Charlotte looks awkwardly elegant with her patchwork dress and patent-leather handbag, which she holds tightly to her chest. She says that during the war, she would run outside to pump water and dash as quickly as she could back to her house because she was terrified

Right: Markets bustle with many sellers but few buyers.

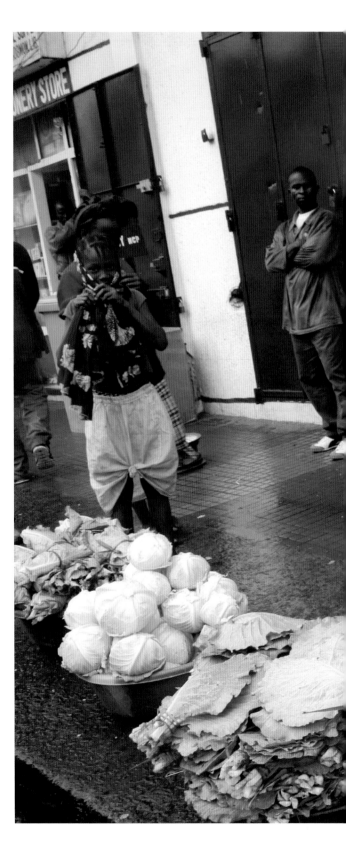

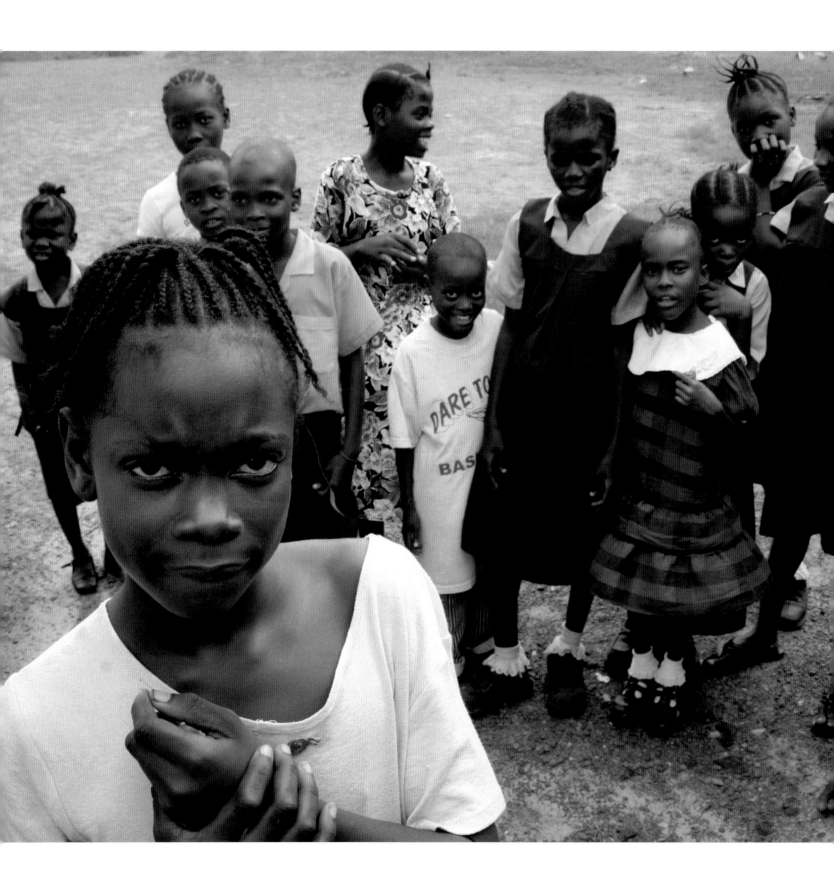

"The president is not interested in wars. She wants to put our children to school," says one voter.

of getting caught in a rocket attack. I learn that many of her classmates lost family members due to the fighting.

The girls and I start playing a game I call "Ask the president." I tell them that they can ask any questions they want, and I will relay them to President Johnson Sirleaf. "Can I be a doctor?" asks Charlotte. "Or a scientist!" shouts Senebu. Then she adds, "Are we going to have electricity?"

Two days later, I arrive for my meeting with President Johnson Sirleaf on the fourth floor of the Liberian Presidential Palace, which is hardly palatial. The president's offices are decorated with red carpeting and antique furniture, but the floors below it are wrecked by years of looting. Barefoot men repair walls with drills while women in bright-colored dresses clean cracked windows.

The lobby is a dramatic portrait gallery of the men who have led Liberia. I can imagine the grim guided tour: Here is President William Tolbert, who was murdered by allies of President Samuel Doe, who was killed by supporters of President Charles Taylor, who is currently being tried for war crimes.

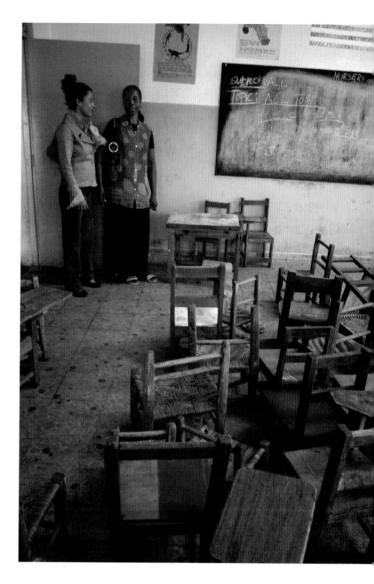

At the end of this collection of power-hungry men is a smiling photograph of President Johnson Sirleaf, looking regal in her traditional outfit of yellow.

When I enter her office, the president has the pained look of someone who is about to sit in a dentist's chair. I sense that she is not thrilled with the press. Since her election, she has answered many questions about Liberia's woes, and early in her tenure she was criticized for her reluctance to push for the prosecution of President Taylor, her predecessor. (She had expressed concern about backlash from his supporters.) "Sick of the media?" I ask. She raises her eyebrows, sighs and gives me a slight smile. There's something grandmotherly about her, with her round face and curly hair, but behind her gold-rimmed glasses is the determined gaze of a woman on a mission. I can see why she is called the Iron Lady here.

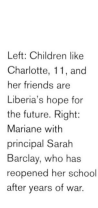

Left: Children like Charlotte, 11, and her friends are Liberia's hope for the future. Right: Mariane with principal Sarah Barclay, who has reopened her school after years of war.

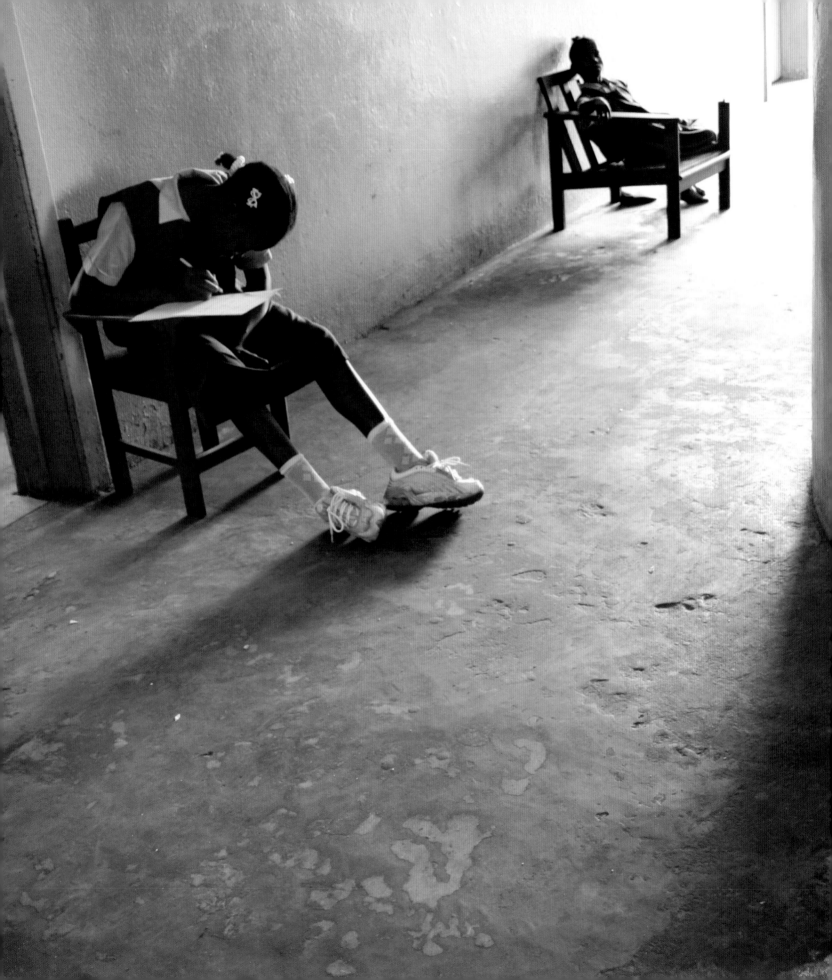

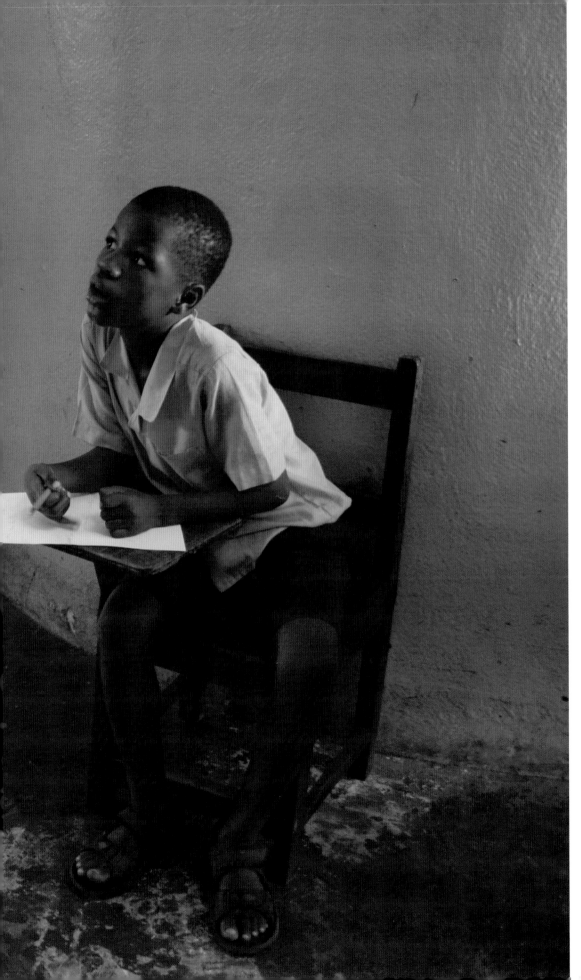

A few years ago, no girl here could have dreamed of being a scientist.

Students take a test in a hallway at a school in Foya; President Johnson Sirleaf has made education a top priority.

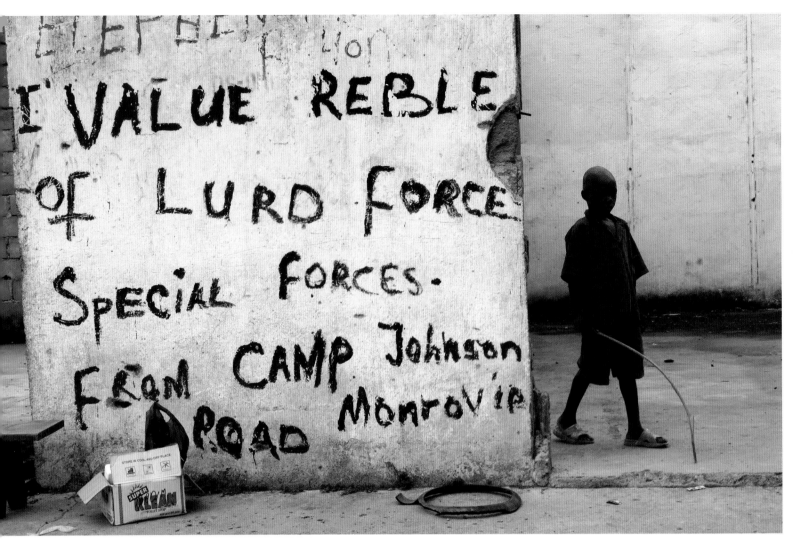

"Why are you journalists always focusing on what is wrong?" she asks. "Why don't you see the beauty of our continent? Why don't you see the women who walk miles under the sun, work 14 hours a day and then go home and wash their children's clothes so they can be clean for school the next day?"

She tells me her biggest task is "to provide dignity, hope and education to a deeply wounded youth." This mother of four learned the importance of schooling from her own mother, a teacher. "My mom would travel by canoe to different schools to teach classes," she says. "She knew that education was the only true road ahead."

Above: Graffiti in Lofa County, a stronghold for rebels during Liberia's civil war. Right: A sign in a Monrovia school.

A graduate herself of Liberia's schools, the president also earned a master's degree from Harvard, then spent several years abroad working in finance. Between foreign jobs, she got involved in Liberian politics. In 1997 she ran against Taylor for the presidency and lost. In the 2005 election, her opponent was George Weah, a popular soccer

star; she won, she says, by appealing to the hearts of mothers with her vow to put kids back in school.

When I tell her of Charlotte's and Senebu's questions, she lights up. "See how the ambitions have changed!" she exclaims. A few years ago, no girl here could have dreamed of being a scientist. "It is thanks to our struggle for gender equity, the feminine revolution," the president says. She turns to her aide and adds, "This is what we need to do: Talk to the children."

As our interview draws to a close and I think about the enormous challenges she faces, I can't help but ask, "How are you going to manage?" President Johnson Sirleaf shrugs, more a pragmatic gesture than a resigned one. "Deeds say more than words. I am going to set an example, like shaking the hands that have hurt me. This is the only way I can free myself and inspire my country."

Before leaving her office, I glance out the window and see two men sweeping dirt from the pavement, revealing a freshly painted Liberian flag. It's an eloquent metaphor for a country struggling to heal itself and move on from the past.

The next day at dusk, I hire a driver to take me back to the airport for my trip home. It is pouring, the rain creating gigantic ponds bordered with mud and garbage. The car's headlights reveal only the rainfall and an occasional man by the side of the road, walking bent over as if to keep his middle dry. My driver is visibly

"Deeds say more than words. I am going to set an example... This is the only way I can free myself and my country," says the president.

nervous. The night looks so dense, I feel as if it could swallow us both. I wish I were driving; at least then I would have a wheel to hold on to.

Finally the airport appears, like a mirage—but it seems that we haven't made it in time. "The flight is closed," says a laconic airport employee. Faced with the dreadful prospect of a ride back to the city with no streetlights, I grab an immigration officer and promise him a bribe to get me on the plane. I run with him onto the tarmac, holding my $50 bill tight, until a flight attendant sees me coming.

When the plane takes off, my heart is beating fast—the danger is past, but it takes a while for me to feel safe. Once again I stare out the window into the darkness below. I'm unable to take my mind off the woman I came to meet and her vow to redeem her people through education. I can't think of many world leaders who say they will make that a priority and actually mean it. I remember the schoolgirl who asked whether the electricity would be turned on in her city. "Yes, Senebu," the principal told her, putting her hand on the girl's head. "Light by light, the electricity will come back."

After years of conflict, many Liberians find peace attending religious services. Above: A Pentecostal church service. Right: A woman worships at an Episcopal church.

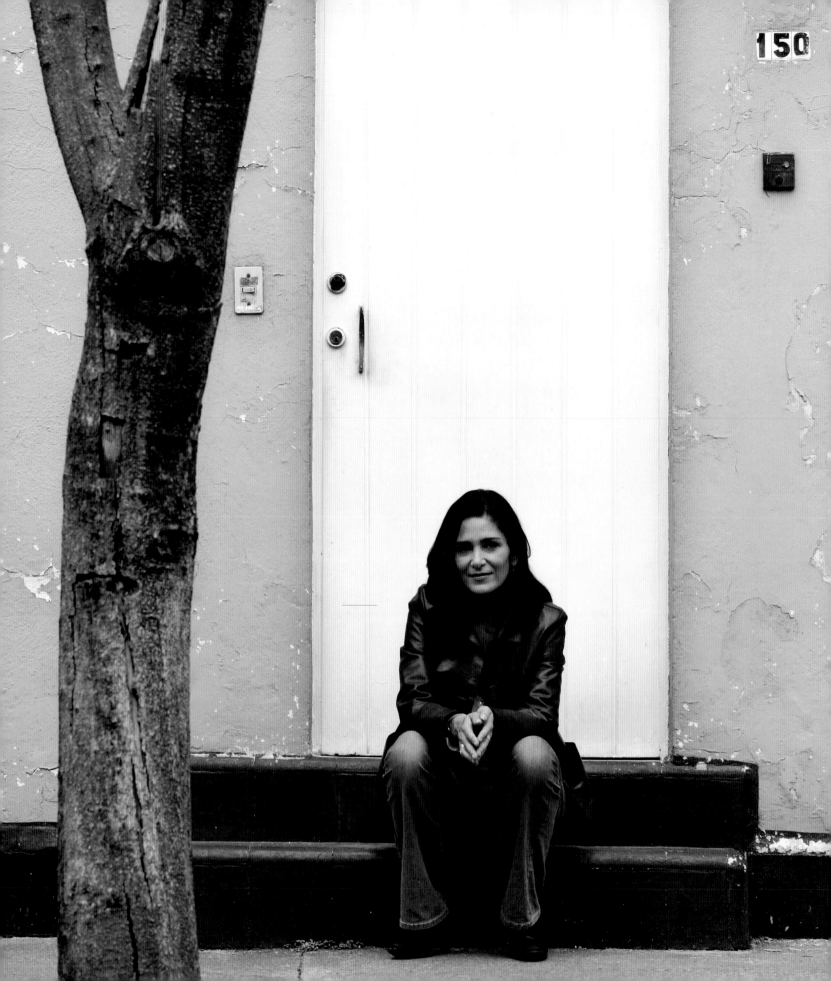

CHAPTER FOUR
Justice Gets a Voice

LYDIA CACHO | MEXICO | AUGUST 2006

WHEN I FIRST HEARD ABOUT MEXICAN journalist Lydia Cacho and the kind of work she's been doing, I started to wonder whether reporters were becoming an endangered species. Across the world, the kidnapping and murder of journalists has escalated since Danny's death in 2002. Iraq has been especially dangerous, with more than 100 media professionals dying within its borders since the war began. In Asia, more than 500 journalists have been attacked or threatened. Many people are unaware that Mexico is the most dangerous place to be a reporter in the Western Hemisphere. More than a dozen journalists have died in the past few years for writing about the country's drug trade and other criminal activities.

Left: Journalist and human rights activist Lydia Cacho. Above: Her book, *The Demons of Eden*, exposed a pedophile ring.

Despite the grave risk involved, Lydia created an international uproar in 2005 after she wrote a book claiming that local power brokers were tied to a pedophile ring in the popular resort town of Cancún.

PHOTOGRAPHS BY ADRIANA ZEHBRAUSKAS/ POLARIS

> *Lydia strikes me as incredibly composed for someone who's forced to consider that every morning might be her last.*

I wanted to meet with her, but she (and I) had a problem: Many people wanted her dead. For the past two decades, this beautiful 43-year-old has given a voice to Mexico's women, children and victims of abuse. She has written about everything from domestic violence to organized crime to political corruption. As a result, she has been jailed once and constantly threatened with death. Now she travels with bodyguards almost everywhere she goes.

I thought about this as I sat in my apartment in Paris one evening and watched my four-and-a-half-year-old son, Adam, play by my side. He was wearing a Superman cape on top of a Zorro outfit and chasing bad guys with his water gun. If only water guns would do it, I thought. He had already lost one parent who was following an important story. Like any journalist, especially those with kids, I had to consider my choices. I thought of the Russian journalist Anna Politkovskaya, who was murdered in 2006 in a suspected contract killing, most likely because of her critical reporting on President Vladimir Putin's war in Chechnya. I met Anna once and will never forget what she said to me. A mother of two, Anna understood the risks of her work, but she also knew the consequences of stopping. "If I don't go to Chechnya," she said, "who will? Who will tell that story?" I understood. The same thing that kept me going after Danny's murder made Anna pursue her investigations: the conviction that you cannot be defeated or defined by the threats of others. With that in mind, I decided to go to Mexico.

For safety reasons, Lydia and I agree not to meet in her

home base of Cancún, but in Mexico City, which was in the midst of its own ordeal during my visit. Following the country's recent presidential elections, thousands of protesters have transformed the city's main avenue into a vast camping site.

Right: Mariane and Lydia meet in Mexico City—for Lydia, safer than Cancún.

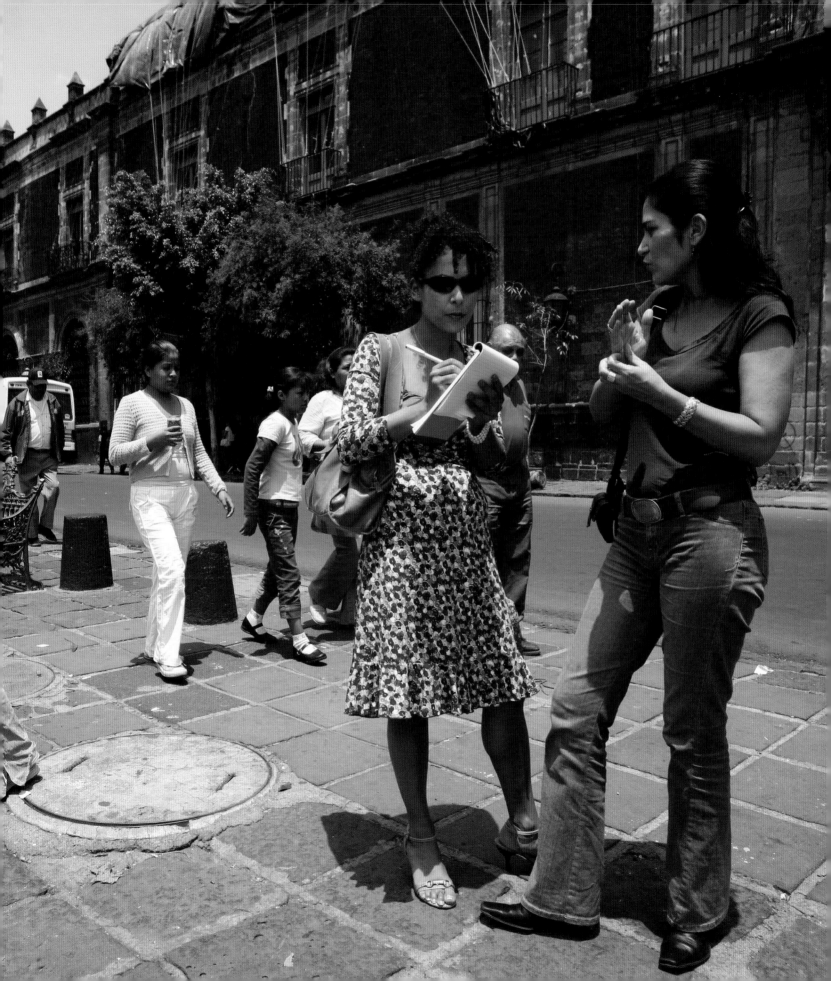

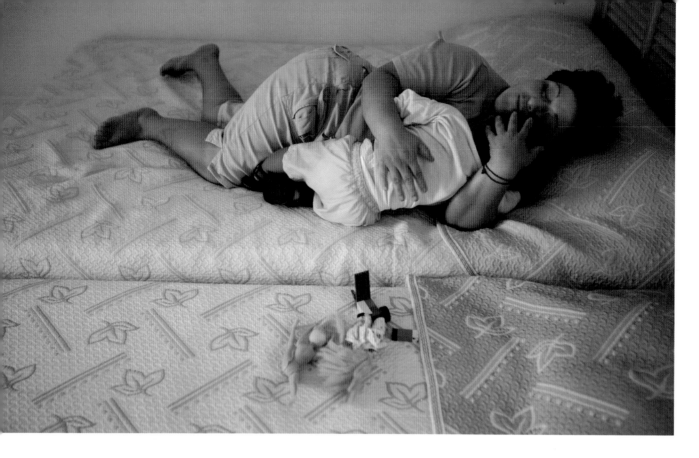

Above: A mother and child at Lydia's domestic violence shelter. Right: Residents of the shelter work on a mural.

People demanding a recount of the votes have come together to shout slogans, wave signs or gather signatures. Everywhere I walk, I feel men's eyes upon me. Some of the stares are harmless, but others are lecherous, making me feel like one of those scary sex dolls with a round mouth. Such a testosterone-filled atmosphere makes me appreciate why Lydia has focused her work on women.

When we meet, Lydia strikes me as incredibly composed for someone who is forced to consider that every morning might be her last. I sit by her side as our car inches along the busy streets of Mexico City, taking us to a quiet suburb. Lydia talks constantly on her cell phone. Each time she hangs up, the phone rings again, and she must reassure the worried people on the other end that she is fine.

She begins to tell me how she got her start in this business. "At first," she says, smiling, "I wasn't sure my writing could make a difference." In fact, when she moved to Cancún in her early twenties, Lydia didn't intend to change the world in any major way. "I am a melancholic at heart," she says half-jokingly. "I pictured myself living by the sea, writing novels and painting." But Lydia comes from a family of strong women who were feminists before the term became trendy. Her French grandmother opposed the Nazis in Europe during World War II, then married a Portuguese man and eventually moved to Mexico. Lydia's mother, who grew up in Mexico, became an activist for women's rights. She felt strongly that it was better to expose her children to the world than to protect them from it, and so the family lived in a poor neighborhood, even though they could afford better. Lydia's mother

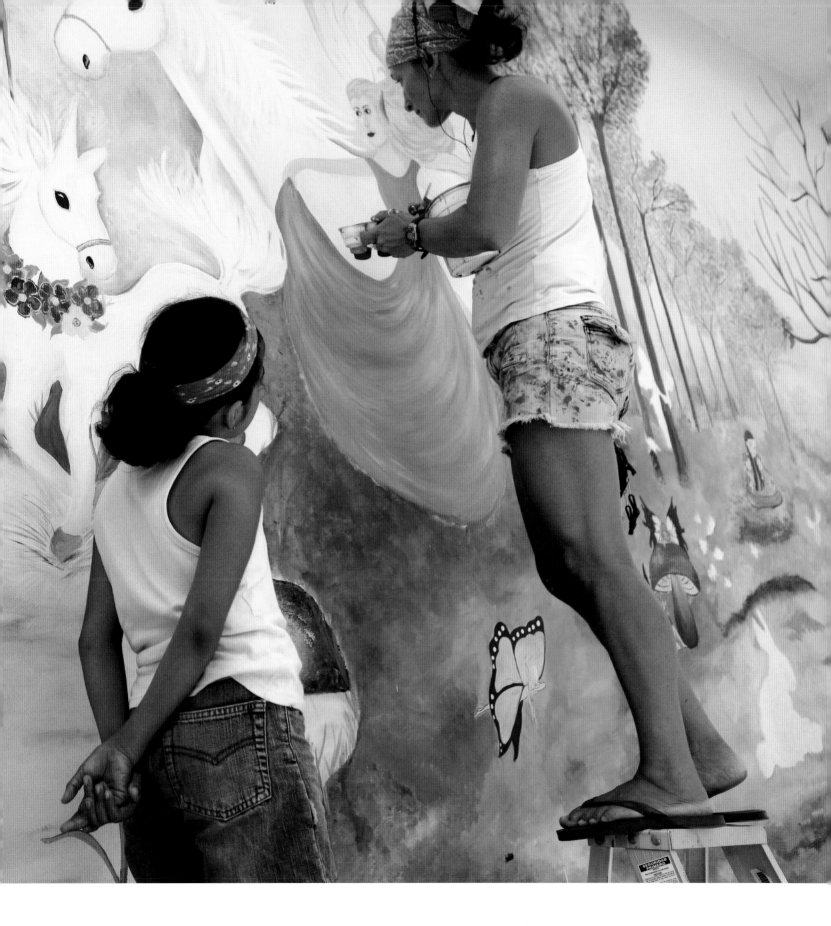

> *Women come to the shelter from all walks of life: wives of drug dealers and farmers, as well as American girls who get assaulted on spring break.*

used to tell her, "Once you have witnessed something, you bear a responsibility for it."

No wonder that soon after Lydia moved to Cancún—a paradise of lush beach resorts—she began to feel a sense of unease. "This was a man-made heaven built solely to make money," she tells me. "It was a city without a heart. Nobody had bothered to think much about schools or social services or even culture." Her journalistic instincts began to kick in, and she set out to find local residents who had been displaced by the builders. She discovered a handful of them in an impoverished community two hours from the tourist zone. "There was no running water. No food. I saw a malnourished woman whose baby had just died of hunger," she says. She decided to write a column about it for a local newspaper. "The reaction was extraordinary," Lydia tells me. Readers were so moved that they donated supplies and medicine. Thus she changed the course of her own life for good, and began to change the lives of others as well.

When Lydia and I finally make it out of the traffic jam in Mexico City, I realize that there are no bodyguards following us. "I lost them!" she says with a childlike smile, and for a moment we feel silly, free, and far away from the world's problems, as if we are characters in one of my favorite movies, *Thelma and Louise.*

Later, as we walk together along the suburb's cobblestone streets, an old man on crutches approaches me. "Is that Lydia Cacho?" he asks. I nod. "Please tell her to be careful," he whispers. "There are evil people chasing her."

Lydia continues to tell me her story, explaining how she made waves again early in her career by writing about the proliferation of HIV in the Cancún area. The local governor called her at 11 on the night the story ran, she says. He told her, "There is no AIDS in my province." She replied, "In yours maybe not, but in mine, yes!" The next day she appeared on a radio show and talked about the call. This very public act surprised her fellow journalists. "Even my colleagues didn't understand me," Lydia says. "Sadly, many Mexican journalists are easy to buy. Some of my counterparts live on bribe money, and those who won't give in to bribes usually get killed."

Lydia kept writing, mainly about government corruption and domestic violence, and soon she began receiving phone calls threatening her life. In 1998 she was brutally beaten and raped in the bathroom of a bus station. Despite suffering a concussion and broken ribs, she got herself to a hospital. Lydia

Right: A child enjoys a slide in the yard of Lydia's Cancún shelter.

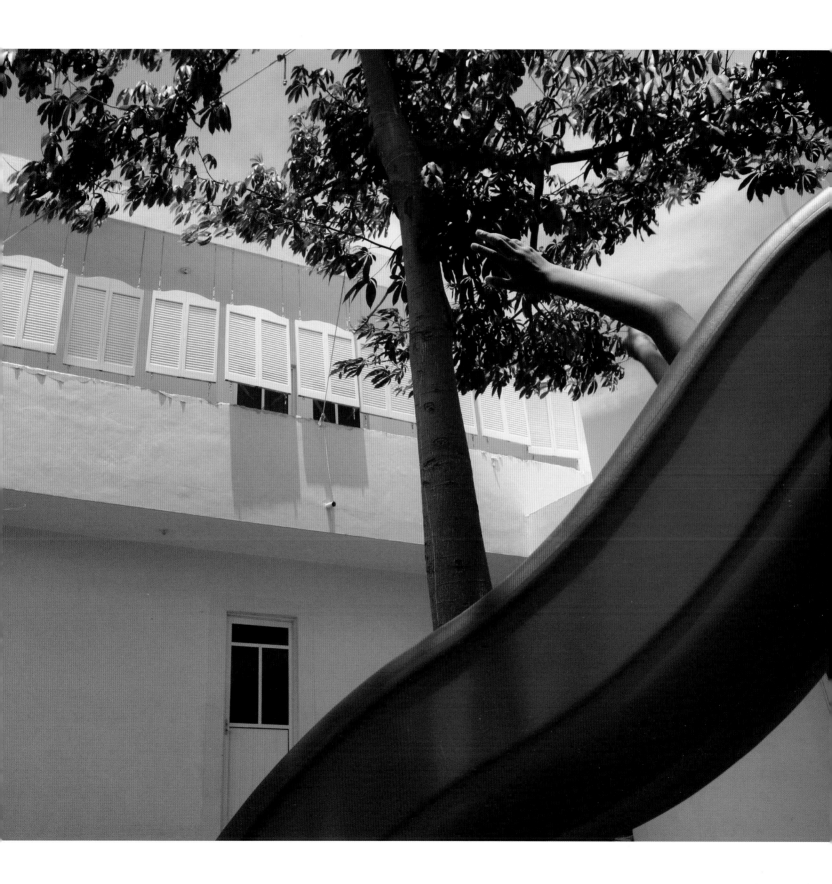

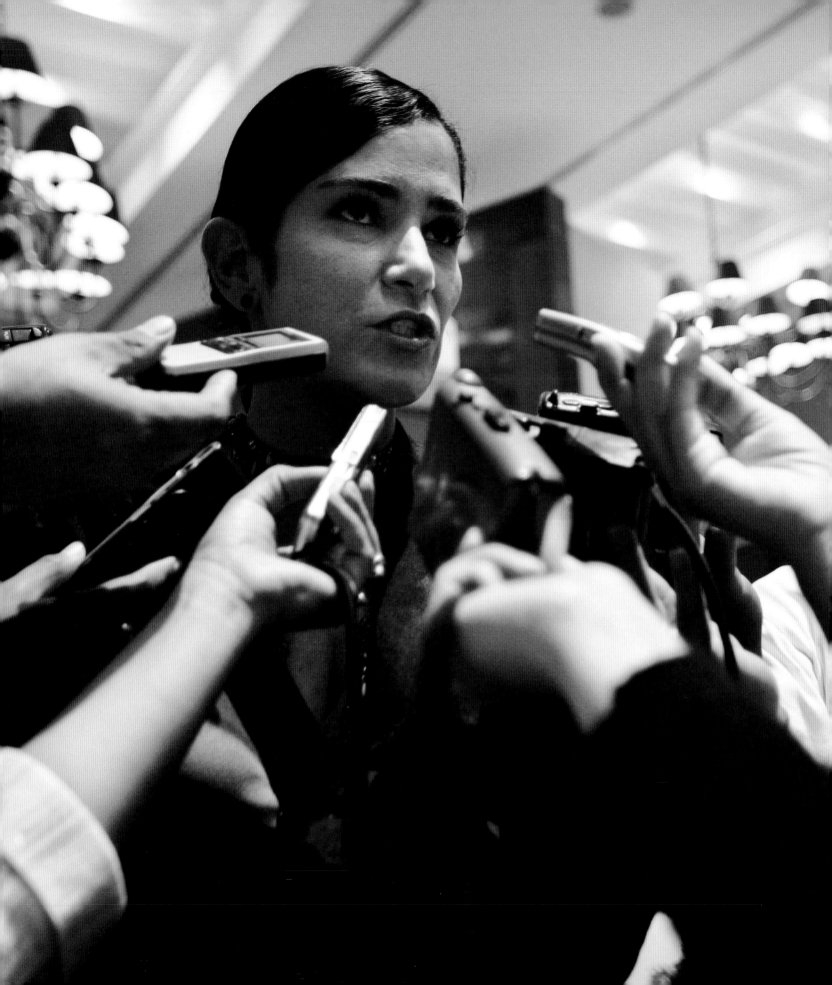

doesn't know whether the attack was related to her work, but the experience made her even more determined to stand up for women.

At the same time, Lydia decided that reporting wasn't enough. So she raised money to build a center for battered women. "Women had no rights, and if they stood up for themselves they could be beaten or killed," she tells me. Women now come to the shelter from all walks of life: wives of drug dealers and farmers, as well as American girls who get assaulted on spring break. The center provides health care and schooling for children.

Lydia set off the biggest firestorm of her career with her book about the pedophile ring in Cancún, *Los Demonios del Edén* (*The Demons of Eden*). She was arrested on libel charges in 2005; under Mexican law, Lydia explains, reporters have to prove that they didn't intend to damage the reputation of their subject. She says she was driven by police to a jail 20 hours from Cancún. During the drive, the officers hinted at a plan to rape her, but ultimately she was released unharmed.

Then, in February 2006, the media got hold of a tape on which a businessman named in her book appeared to be plotting with a Mexican governor to have her arrested and raped. (The men dispute the legality of the tape.) Amnesty International filed protests on her behalf, and Lydia talked about it on shows such as ABC's *Nightline*. "This is my strategy," she says. "Each time someone threatens me, I talk about it publicly."

"This is my strategy," says Lydia. "Each time someone threatens me, I talk about it publicly."

Lydia, who still faces some libel charges, tells me that Mexico's Supreme Court is investigating whether her civil rights were violated during her arrest. She is continuing to work as a reporter while also teaching journalism workshops. "Reporters are not world-peace missionaries," she says. "But by conveying people's struggles, we create awareness, which is the first step to bringing about change."

When I leave Mexico City, I fear for Lydia's life, but I also feel inspired by everything she stands for. I understand her humble sense of triumph. Knowledge and responsibility bring hope, while ignorance feeds fear. If Lydia were to stop now, she would be like someone who sees light at the end of a tunnel but chooses to remain in the dark.

Back in Paris with my little boy, I think about what I would say to him if he ever wanted to become a reporter. I would tell him that journalism—the search for what is true

Left: Local media seek Lydia's input at a conference on sex tourism. Right: Facing libel charges, Lydia signs court papers.

Muérdele el corazón

about our world, whether good or bad—was the cement of my relationship with his father. I so believe in the importance of this profession that I could never oppose the same ambition in my child.

As we are having dinner one night, Adam asks me about my trip to Mexico. He wants to know if I caught any bad guys. "No," I answer. "But wait a few years and I'll tell you about a woman named Lydia."

"Sadly, many Mexican journalists are easy to buy," says Lydia. "Those who won't give in to bribes usually get killed."

Postscript, August 2007: Lydia's life has not become easier. On May 7, while she was driving along a Mexican highway with a friend and three federal agents who work as her bodyguards, their car began to tremble mysteriously. The agents later discovered that one of the rear tires had been tampered with and loosened. The attack could have caused a serious accident at high speed, but this brush with danger—and the daily threats she continues to receive by phone—hasn't slowed Lydia down.

If anything, she's more emboldened than ever to fight injustice. One alleged pedophile exposed through Lydia's work, Succar Kuri, is in prison awaiting sentencing of up to 16 years in a child pornography case. (It's the first time that Mexico's highest court has accepted a human rights case brought by a woman.)

And since this column was published, international organizations have begun to recognize Lydia's work. In March, she won the Ginetta Sagan Award from Amnesty International, and this fall, she will receive the Courage in Journalism Award from the International Women's Media Foundation, an honor bestowed on journalists who risk their lives in the name of truth, as Lydia continues to do each day.

Left: A copy of Lydia's 2006 novel, *Bite the Heart*, inscribed for Mariane. Right: An armed (female) bodyguard, Lydia's necessary companion.

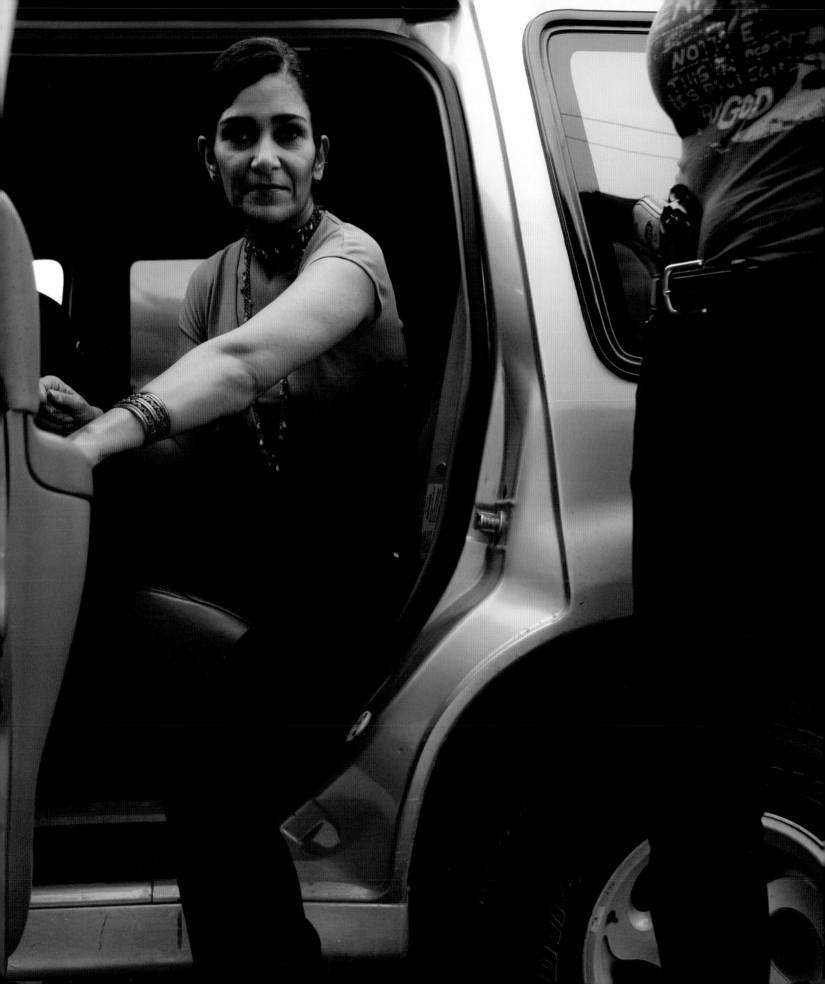

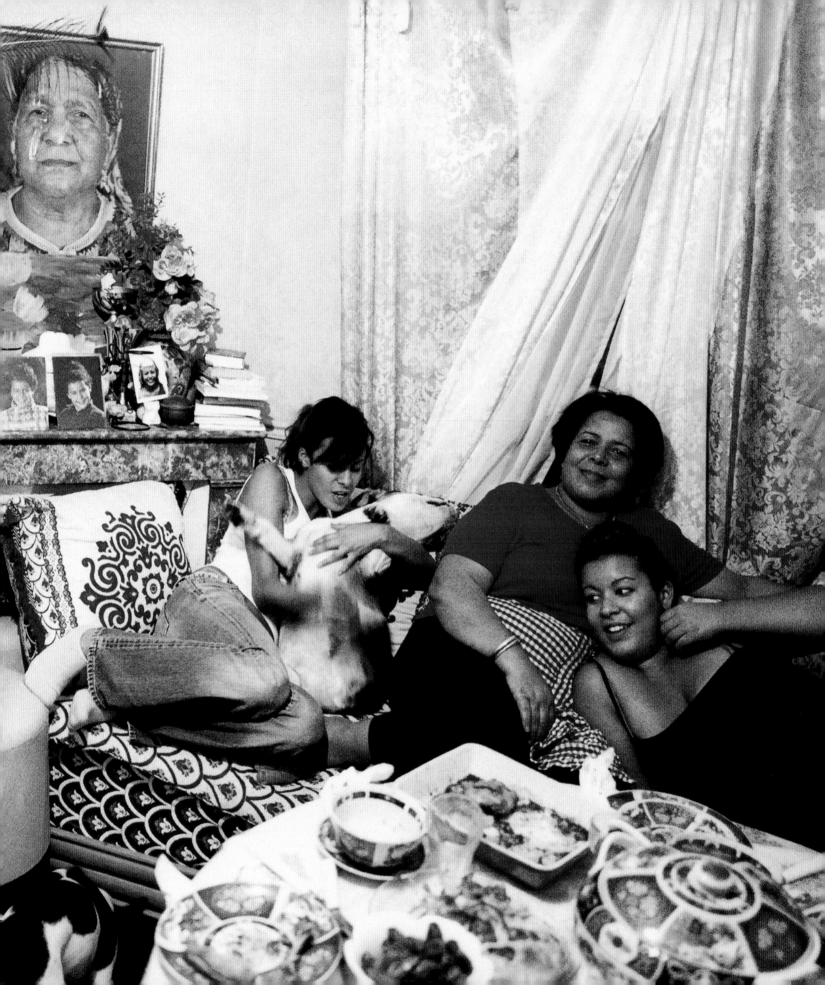

CHAPTER FIVE

No Longer Invisible

FATIMA ELAYOUBI | FRANCE | SEPTEMBER 2006

WHEN I TELL PEOPLE I GREW UP IN PARIS, they consider me blessed. Paris is the most romantic city in the world, after all, with its beautiful river and its ancient bridges where lovers have kissed for centuries; it is the heart of fashion, elegance and art. But there is another side to Paris that the world does not know so well—a part of the city that only someone like Fatima Elayoubi knows.

Fatima is one among thousands of Moroccan, Algerian and Tunisian immigrants who came to Paris in the eighties to make new lives for themselves. Most ended up near the bottom of the cultural food chain—in low-paying jobs and cheap cluster-housing flats on the outskirts of the city that Parisians refer to as chicken cages, their rows of concrete buildings reminiscent of subsidized housing projects in America. After traveling

Left: Fatima with daughters Mariam and Sokaina beneath a portrait of Fatima's mother. Above: A Muslim prayer book, in French and Arabic.

PHOTOGRAPHS BY SIMON WHEATLEY/ MAGNUM PHOTOS

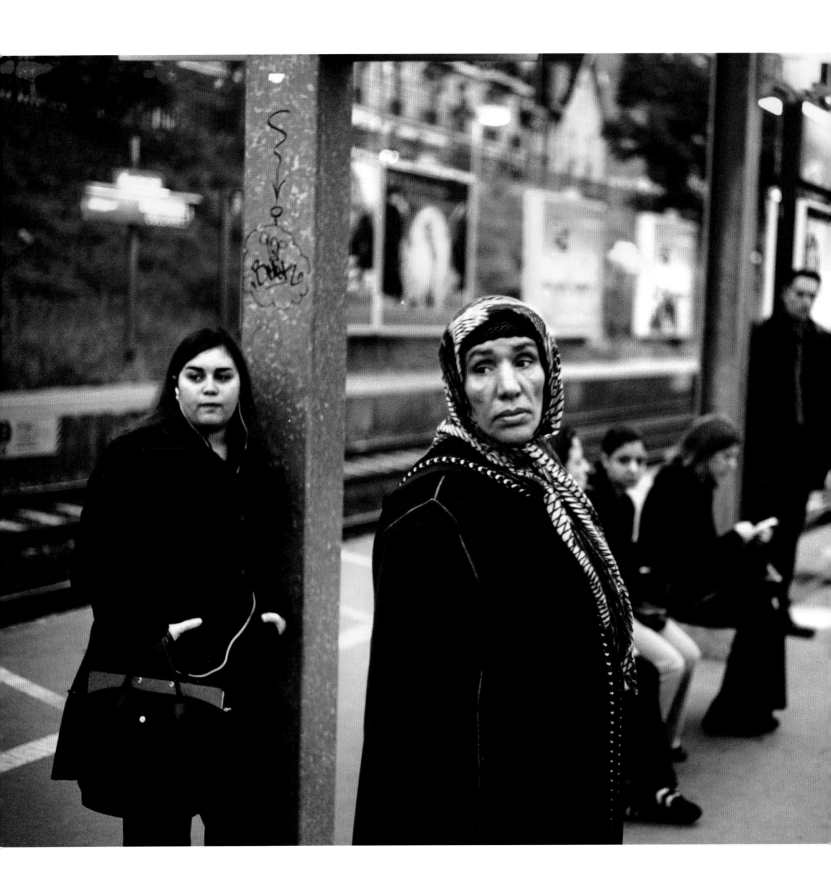

to less familiar parts of the world, I feel it's my duty to find out what's happening right here in my backyard.

I spent a lot of time in the Paris suburbs during my early years as a reporter, and I met many immigrants who felt inadequate and powerless. Once, I sat with a man named Mustapha as he replied to a job ad. To prove a point to me, he called twice, first using a French name and then his own name. With the French name, he got an interview; with his own name, he was told the job had been filled. When he hung up the phone, his hand was shaking. This is what injustice feels like, and it is this kind of frustration, rooted in race, religion and identity, that last year drove the kids of immigrants to set hundreds of cars on fire in riots around Paris, and earlier this year to torch buses in another display of fury.

Fatima's small home in the somber Parisian suburbs is a nostalgic tribute to her native Morocco and the family she left behind more than 20 years ago. On the wall, a clock with a picture of Mecca ticks away the time. The dining table is draped with a cloth Fatima knitted herself, and in the corner of the living room is an enormous photograph of her mother, her face wrinkled by a life spent under the North African sun. Poorly educated, Fatima—like many Arab immigrant women—spent years in the shadows, cleaning, cooking and doing the laundry for better-off French families.

But Fatima, 54, eventually achieved the unimaginable for a woman of her background. Each night, after she finished scrubbing other people's homes, unnoticed and anonymous, she'd sit in her own tiny kitchen. Staring out the window, Fatima would recover her self-esteem by engaging in an internal monologue about her personal story. Eventually she turned those private thoughts into a memoir that explored her harsh life as a stranger in a foreign land. Then she had the confidence to believe people should read it. Her book, *Prière à la Lune* (Prayer to the Moon), became a surprise hit—one that revealed to Parisians the lives of a population they had long ignored.

Fatima's book became a surprise hit—one that revealed to Parisians the lives of a population they had long ignored.

Left: A woman waits for a train in the Paris suburbs.

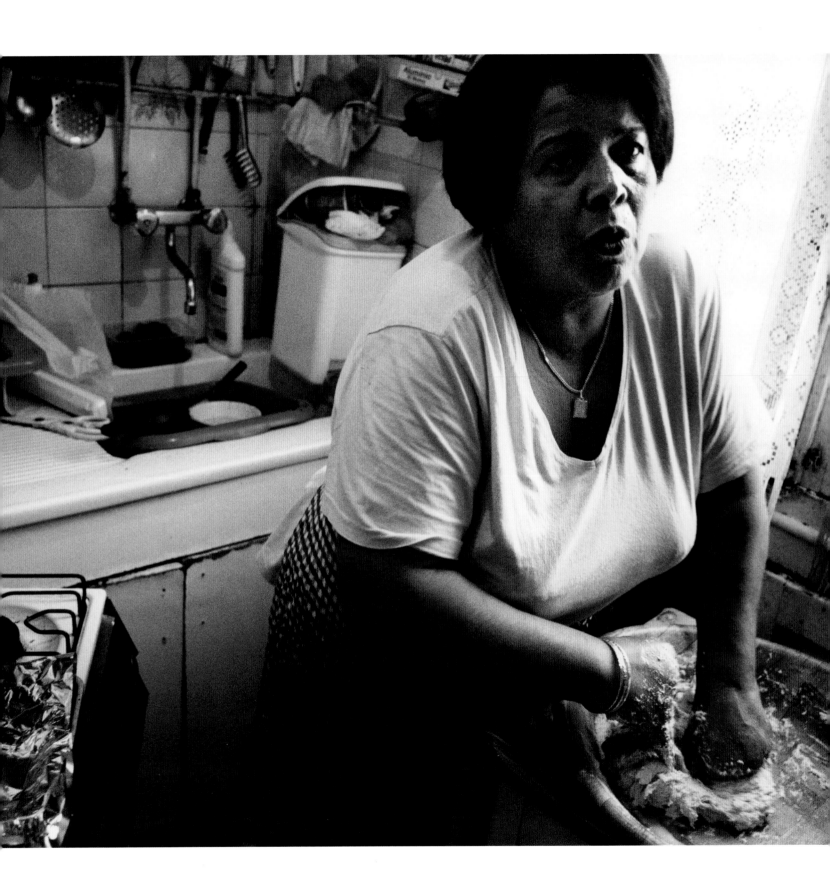

Fatima's life story

is typical of that of Arab women of her generation. In her book she tells of her life as a girl in Morocco. When she was 12, she left school because her parents could afford to educate only her two brothers. So she set aside her girlhood dreams of studying literature and instead lived at home, helping her 11 sisters learn to read, sew and cook. Eventually she wed a man who brought her to France and fathered two girls; later he and Fatima separated. To feed her kids, Fatima cleaned as many as five homes a day, getting up at four in the morning, scouring floors, losing her self-esteem and, she says, "forgetting my own femininity."

In *Prière à la Lune*, Fatima describes the difficulties of trying to assimilate French society while also maintaining her Arab heritage. She tells how she strove to help her daughters navigate the two worlds, but as they neared adolescence, they grew increasingly distant, even hostile.

One day Fatima collapsed as she carried a vacuum cleaner down a flight of stairs, and when she fell, she broke what she calls "my only diploma"—her body. For the first time in her life, she crawled into bed and could not find the strength to get up again. Her anguish peaked when one of her girls asked for help with her schoolwork. "Do you know how it feels to have your child crying because her mother can't read or write in French?" Fatima asks. She knew she couldn't learn French quickly enough to help her child, but she could give her something else. "I understood my daughters needed something bigger than me. It wasn't clothes, food or love. It was knowledge. It was culture."

So she sat by the window and painstakingly began to write, using the Arabic she'd learned at school. She "wrote to the moon," she says, her silent companion, the sole witness to her life as a woman with a past, a religion and a soul. Her style was poetic: "We have discovered the secrets of the earth," she wrote. "We have found wealth at the bottom of the ocean and fetched stones on the moon, but we can't see the treasures we have at arm's length."

Left: Fatima prepares a Moroccan meal. Above: Her daughter Mariam, 21, is caught between two worlds, trying to be a good Muslim and a typical French girl.

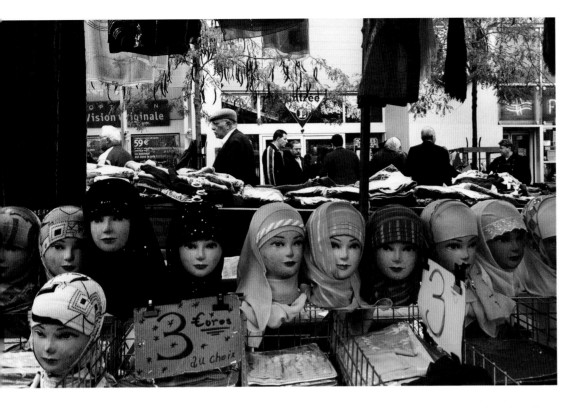

Fatima introduced herself to elite editors at a book fair, and a publisher soon came calling.

Above: Traditional head scarves on sale at a neighborhood stand. Right: Shopping in the local market.

As Fatima and I talk about those days, her daughter Sokaina, a pretty, plump 18-year-old, bursts through the door. She is followed by her sister, Mariam, 21, who arrives wearing a T-shirt and sexy white shorts. The radio is playing Arabic songs, and the small flat smells of couscous, a traditional Moroccan dish. Mariam has brought her two "babies," a pair of bulldogs that frantically search the place for interesting new odors. I glance out the window, thinking about Fatima writing "to the moon," and wonder whether it is even possible to see the moon from here.

The girls gather near us while Fatima continues telling me about her odyssey, and about the time she sought help from a psychiatrist. "This was the first time I shared my life with anyone," Fatima says. She talked about her writing, and the therapist helped her find someone who could translate her story into French for free. Reenergized, Fatima visited a book fair and introduced herself to elite editors, who expect their writers to have years of education. Remarkably, a publisher called soon after.

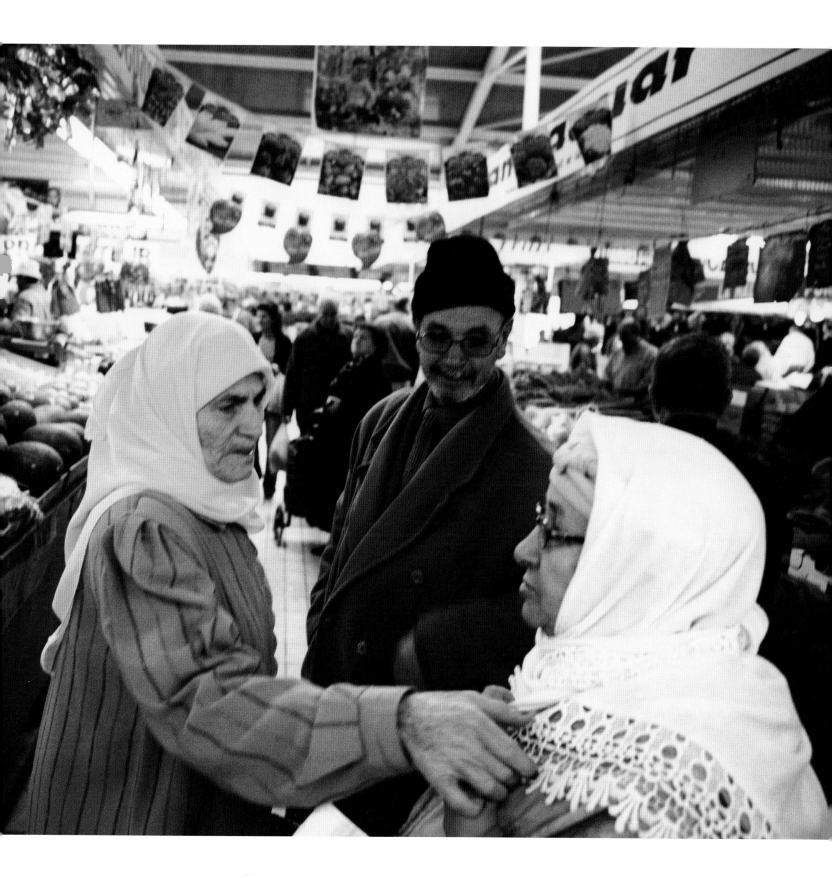

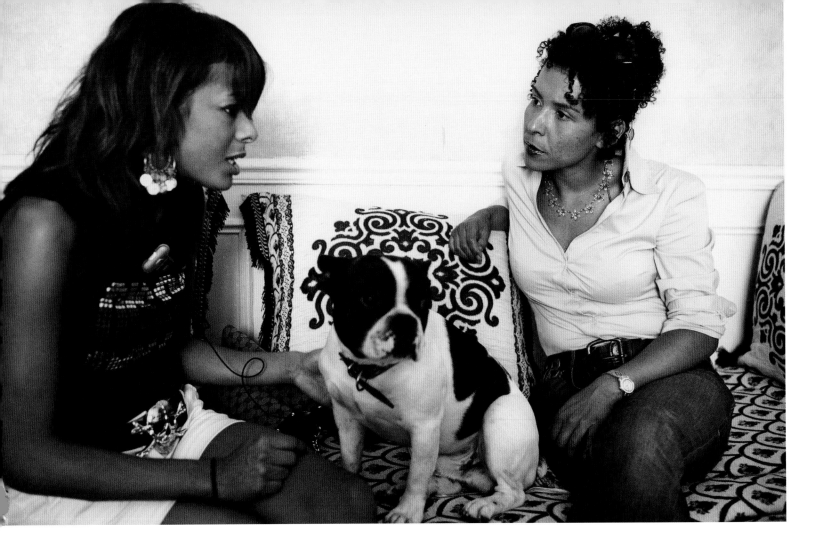

"I don't know who I am," Mariam says. "I am both a die-hard party girl and a deeply religious person."

As Fatima gets up to attend to the couscous, I chat with Sokaina, a high school student, and Mariam, who's between jobs but tells me she used to make good money working in a bar at night. The girls are what French people call *beurette*, a slang term derived from the French word for butter, referring to their luminous skin tone. They remind me so much of the Muslim friends I had at their age and how they struggled. Being a good Muslim and a typical French girl meant bridging an impossible divide. At school you had to be hot; you had to wear makeup and drink at parties, but at home this behavior was considered a sin. If you didn't have sex with boys, you were a prude; if you did, you were a whore. Things have only gotten worse since then: Increasingly, girls who flout traditional Muslim notions of modesty are being attacked by youth gangs; one young woman was even burned to death in 2002.

"I don't know who I am," Mariam says. "I am both a die-hard party girl and a deeply religious person. Sometimes I am one, sometimes the other, but I can never be both." As Mariam confides in me, she looks fragile. She is constantly laughing,

as if to downplay her struggle. "When you're Arab, everyone judges you," she says. "The worst comes from within the community."

Like Mariam and Sokaina, I grew up as an immigrant in Paris. But my ethnicity—Cuban and Dutch—was deemed exotic, and I never felt discriminated against, unlike the kids whose parents came from North Africa. My mother single-handedly raised my brother and me, and we barely made ends meet, but I was lucky: I lived inside the city and not in its grim suburbs. And, in another profound difference between other immigrant kids and me, I was utterly proud of my mother. My Muslim friends rarely mentioned their parents. Their moms and dads, with their unglamorous jobs and foreign values, were a matter of discomfort or shame. Even now, there are immigrants I've known for decades who have never told me what their lives were like at home, or what their parents did for a living—let alone how they might've felt about trying to navigate two different worlds at once.

That is why I know how courageous it is for Fatima to share her life and put a face on all the invisible immigrant mothers. Ever since her book was published last year, she

Left: Mariam talks with Mariane about life in the Paris suburbs. Above: The family sits down to a meal of couscous.

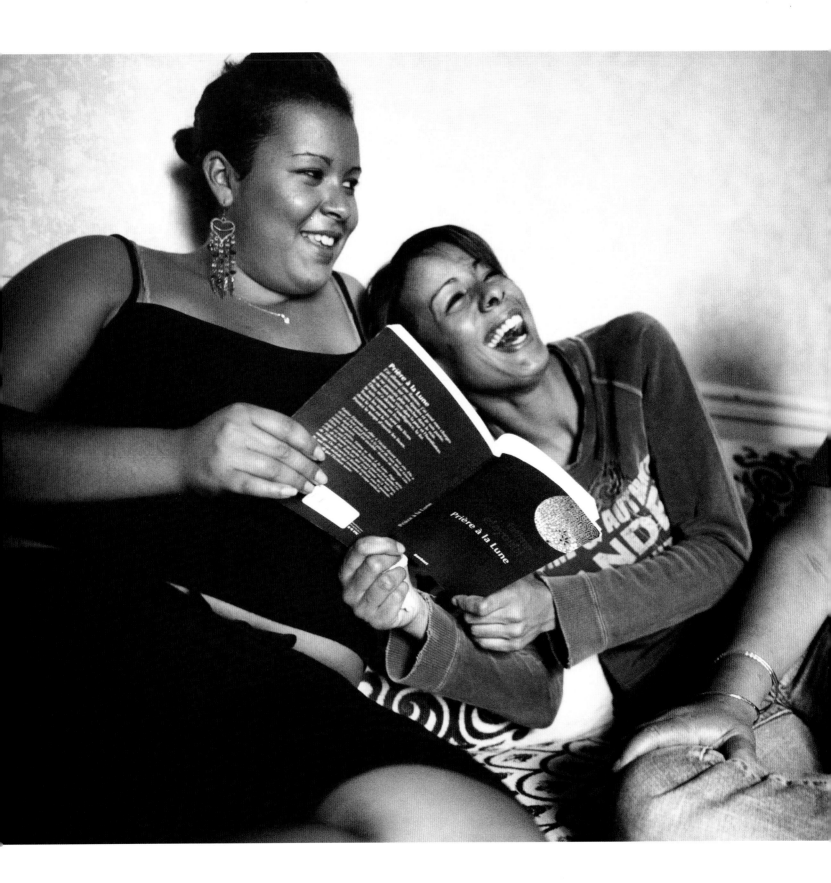

has been all over the French media. Professors are discussing how astounding it is to hear an authentic voice of a long-silent community. The people in the homes Fatima once cleaned are suddenly taking notice of the great distances their workers travel to their jobs. Says Fatima, "We know French people. We go to their homes and clean their dirt. But until now, the French didn't find it necessary to discover who we immigrants are as people." Fatima no longer cleans homes and is writing another book, also autobiographical.

In the flat's only bedroom, I hear Fatima's girls giggling and arguing gently over clothes. "Shhh," says Fatima, turning on the radio. She's about to be featured on a popular news program. As the taped segment starts, everyone falls silent, listening to the unlikely voice of Fatima, the cleaning lady.

Once the show is over, the girls tell me they didn't really understand that their mom was writing a book until it was finished. "I would come home at three in the morning and see her bent over the dining room table with her big glasses, crossing out words and rewriting them," Sokaina says. She waves a copy of *Closer*, a French tabloid, and turns to a page featuring her mother. "You know what is probably the most beautiful moment of my life?" Sokaina asks. "It was not so long ago, when I was filling out papers for my school. In the 'mother's profession' box, instead of putting the usual 'cleaning lady,' I got to say, 'My mother is a writer.'"

"I understood my daughters needed something bigger than me," says Fatima. "It wasn't clothes, food or love. It was knowledge. It was culture."

Left: Fatima and her girls share a laugh while reading her book, *A Prayer to the Moon*.

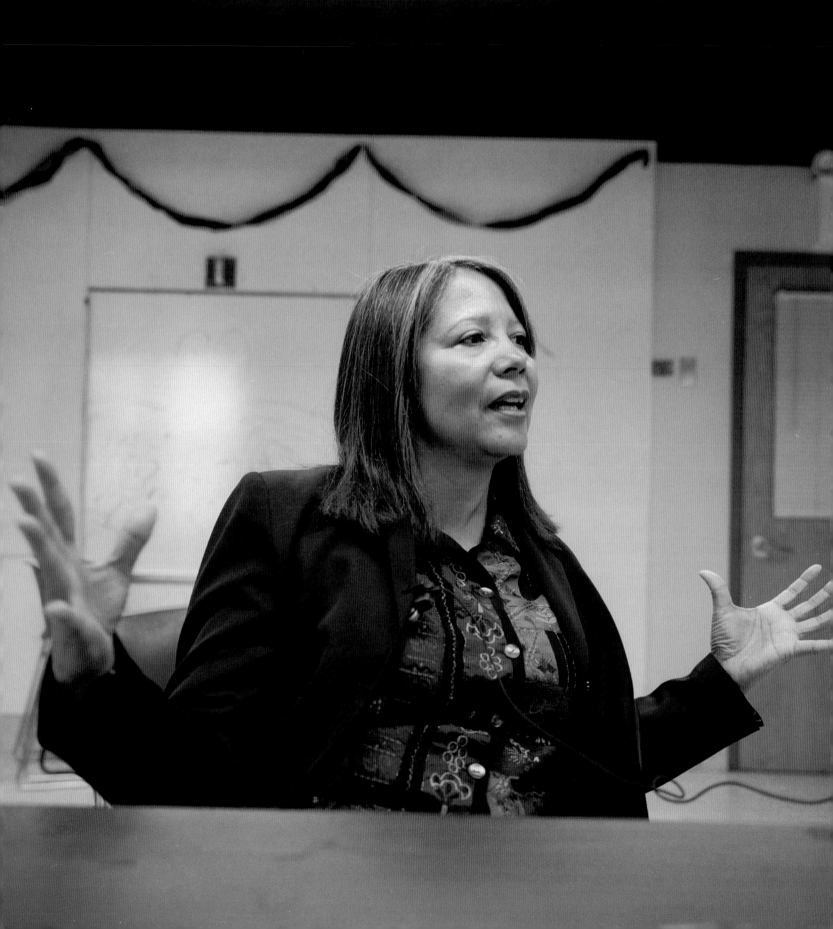

CHAPTER SIX

A Leader for Lost Children

ANGELA DIAZ | NEW YORK | OCTOBER 2006

AT 17, I DECIDED I NEEDED TO GET AWAY FROM

Paris. I had recently discovered my father's suicide note, which explained why he'd killed himself when I was little. Until that moment, I'd believed he had died of natural causes, and with the shock came an overpowering urge to force a dramatic change in my life. I made a snap decision to move in with an uncle in New York, and I set an unrealistic goal of becoming a dancer. All I knew were a few salsa moves I'd learned from my mom, but in my imagination there was little doubt I could make it. The New York I fancied was all glittery lights and endless opportunities.

My illusions quickly faded when my uncle picked me up at the airport in a surprisingly long and beat-up Dodge and we drove to his tiny, one-bedroom apartment off Fordham Road in the Bronx. I watched as the majestic Manhattan skyline gradually turned to rows of charmless,

Left: Angela Diaz, M.D., knows firsthand how tough New York can be for kids. Above: A New York City souvenir.

PHOTOGRAPHS BY GILLES PERESS

Thousands of young people who visit Angela's center look to her as a surrogate mother.

Above: Endless case files at Angela's center. Right: A street in Harlem.

graffiti-covered four-story buildings. Out the car windows, I heard the language switch from English to Spanish, and the skin tones changed from white to brown. "Welcome to New York," my uncle said cheerfully. Welcome to reality, I thought to myself.

In the two years that I lived there, I discovered that in spite of a 20-block walk to the subway, my reality was actually not so bad, compared with what some of my friends struggled with. So many of them were troubled, lonely or angry—economically deprived kids whose parents didn't speak English (my uncle didn't either), or whose families had imploded due to crime and drugs. The gap between my romantic idea of New York City and the reality of the barriers created by poverty and language was so large, I wondered if my friends would be able to overcome it. As for me, I never made it as a dancer. I left the city and went on with my life. But I never forgot my Bronx friends, their little brothers and sisters, and more children coming up behind them. Who would be there for them when they needed help? Who might help them close that gap, so that they might safely make their way?

This is why it means so much to me to meet Angela Diaz, M.D.—a child of the same Bronx that caused my friends to despair. Elegant yet casual, dressed in a brown blouse and a necklace the color of a sunset, Angela walks me briskly through her domain, the Mount Sinai Adolescent Health Center, just blocks from New York City's Harlem neighborhood. As we pass the gray-walled examination rooms, Angela lightly brushes the cheek of a bored teenage boy listening to his MP3 while he awaits his turn. She teasingly squeezes one secretary's shoulder and stops to praise the work of another. No wonder people see her as a kind of surrogate mother, one with an ever-expandable heart capable of caring for the 10,000 impoverished young people who visit the center each year seeking treatment for everything from HIV to depression to the effects of incest.

As down-to-earth as she seems, Angela is already a living legend, and all the kids here know the story that makes her so special: Their world-class pediatrician, the woman who turned this clinic into the country's largest free adolescent health care facility, was once a confused and directionless teen who got help at the very center she now runs.

"Because of my own experience," Angela says, "I know for sure that one person can make all the difference."

Mariane and social worker Adam Melaney in Harlem.

Angela sees her mission as healing both minds and bodies.

Just like the kids at her clinic, Angela, 52, started life at the bottom of the social ladder. She grew up in poverty in the Dominican Republic and lived there with her grandmother after her parents immigrated to the United States. At age 12 she arrived in New York for a temporary stay, landing in one of the city's toughest neighborhoods, the South Bronx. "Me no English" were the only words she knew, says Angela, laughing at the memory. She was alone, and lonely—her mother had to work two factory jobs and never took a day off. "I felt trapped within the walls," she remembers.

After she permanently moved to New York as a teen, Angela shouldered an overwhelming load. A good student with dreams of becoming a doctor, she stayed up late

studying and found part-time work to help her family. In high school she juggled three jobs: tutoring other students, working in a luncheonette and helping out at a beauty parlor. "Life was really hard," she says. "I had no outlet, no intimate conversations." Overwhelmed, she dropped out of school just months before graduation. She seemed to be heading nowhere until she did something that changed her life: She paid a visit to a social worker at the Mount Sinai Adolescent Health Center, which was no more than "a trailer in a parking lot," she says. The social worker urged her to open up about things she'd never shared before. "I even talked for the first time about a sexual assault by a schoolmate when I was in ninth grade."

The healing that began there put her on a path that would take her not only back to high school but on to college, then to medical school at Columbia University and then to Harvard's School of Public Health. Throughout her journey, Angela never forgot who had turned her around—the Mount Sinai social worker. "Because of my own experience," she tells me, "I know for sure that one person can make all the difference."

At the Mount Sinai center, I share my own Bronx experiences with a shy and serious African American teenager waiting in an examination room. The girl thinks it's hilarious that I was so naive. She comes to the center to combat the urge to mutilate herself with razor blades. A family member raped her from age 10 to 12, she tells me, and she started cutting herself two years later. "When I cut myself," she says, "I get to control the intensity of my pain."

The teen tells me that most of her friends swallow their anger rather than talk about their problems. Once, she says, "I met up with my girlfriends and learned that four of the five had been sexually molested for years but had never discussed it until that day."

It was helping teens like this, who need to heal both their minds and their bodies, that Angela saw as her mission when she became acting director of the center in 1989. (She took over as official director in 1991.) At first she didn't feel up to the challenge. "I had just finished my pediatric residency, and I had no experience in running any-

Left: Social worker Adam takes a well-deserved break. Above: The entrance to Angela's beloved adolescent health center.

> *Angela's greatest talent is for understanding how desperately teenagers need someone to believe in their future.*

thing. My initial reaction was: I cannot do this." But she quickly got to work. "It was a much smaller program then, less than half the staff, patients and budget," says Angela, who soon began adding programs, including services for the learning disabled and an upgraded drug abuse program. She also hired a psychologist. "Basically, whatever the teens brought us, we tried to find a way to serve them." All the additions fit in with her philosophy: "The thing is, most of these adolescents don't have insurance and don't have money, but I want them to get the same kind of care other kids get. I want them to feel we treat them with respect." Her patients—mostly African American and Hispanic kids between the ages of 10 and 21—get the message. Says Angela, "It's amazing how many come back later and thank us for saving their lives."

Despite the fact that she works constantly—"Friday, Saturday, Sunday…endless hours, because I love it"—Angela has somehow found time to help design adolescent health programs for hospitals from Nigeria to Mongolia, win a slew of awards and raise three children of her own. But her greatest

Above: Hopscotch at a playground near Mount Sinai. Right: Ja-Naya, whose mother has received treatment at the center for years.

> *"Let's face it,"* Latoya says with a smile. *"Family is right here at Mount Sinai."*

talent is for understanding how desperately teenagers need someone to believe in their future.

She tells me that for all the suffering she witnesses, she sees many kids emerging talented and strong. "That's what makes me happy," she says softly, her satisfaction visible in the way she glows. One of her social workers, Adam Melaney, 35, agrees. "We're energized by the kids," he says. With his cool look—he wears a baseball cap and a funky earring—Adam works at reassuring kids that there is hope even if they seem to have lost it. A brochure published by the center sums up the staff's attitude: "Just when the caterpillar thought the world was over, it became a butterfly."

On a chilly afternoon, I walk with another of the center's patients, Latoya, 23, and her three-year-old daughter, Ja-Naya, to a playground near the center. (Latoya began coming to Mount Sinai as a teen; in some cases the center can treat patients up to age 24.) Latoya describes her life as a struggling single mom of two girls. She, too, was sexually assaulted in childhood. "As a kid, I felt my mom disliked me. I even thought she wanted to put me in a group home." Latoya has never seen a photo of herself as a child. "Now," she says, "I can't stop taking snapshots of my kids."

When Latoya was assigned to Adam, who is her social worker, she barely spoke to him for six months. Her biggest fear, she says, was that she'd start crying. But eventually she did weep, and hence began to heal. "Adam is the first person I have ever trusted," she says. Although Latoya has never been treated directly by Angela, she knows all about her. "Angela is my role model," she says.

Latoya's resilience and courage humble me. Thanks to the help she gets and the tears she shed, I know she will protect her kids from a fate like hers. She and I walk back to the center, each of us holding one of the little girl's hands. "Let's face it," Latoya says with a smile. "Family is right here at Mount Sinai." And in that shy smile, I see the ripple effect of human empathy and understand that this is how we can change the world, each one of us. I think of the person who helped Angela become who she is today, and I see what Angela is doing for Latoya and her daughters. All along, it took only one individual who was able to look at the caterpillar and see the butterfly.

Right: Mariane chats with Latoya and another neighborhood resident.

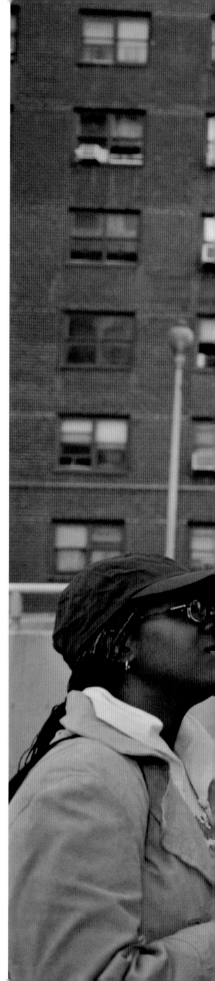

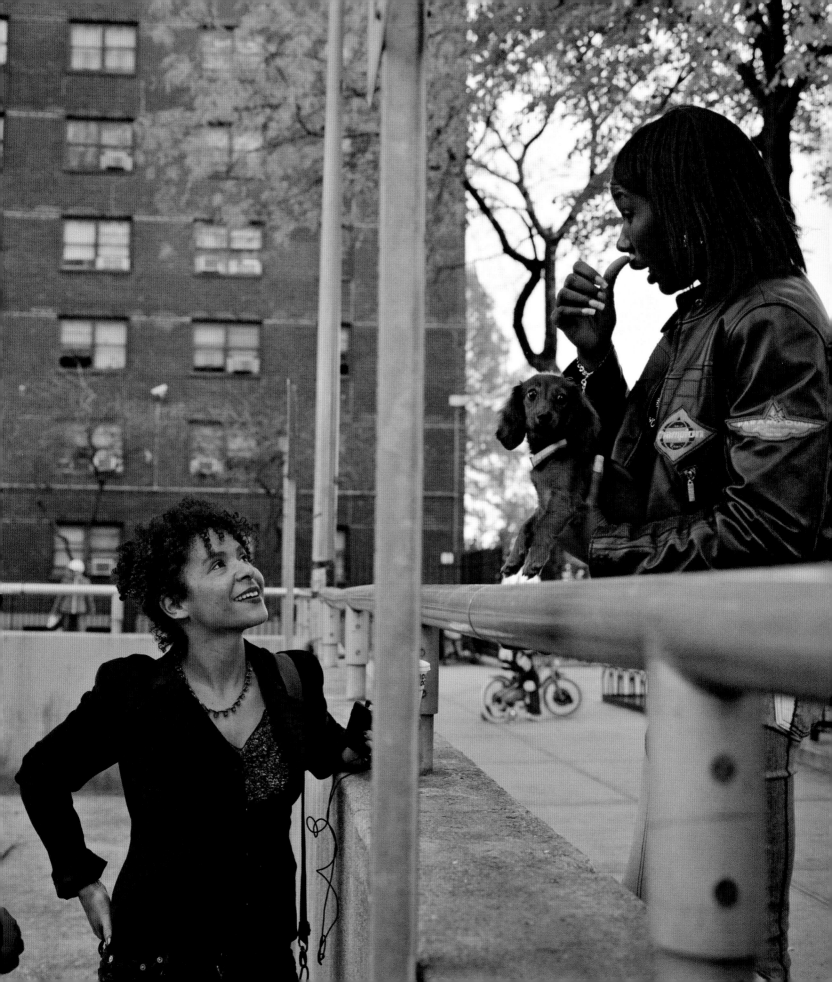

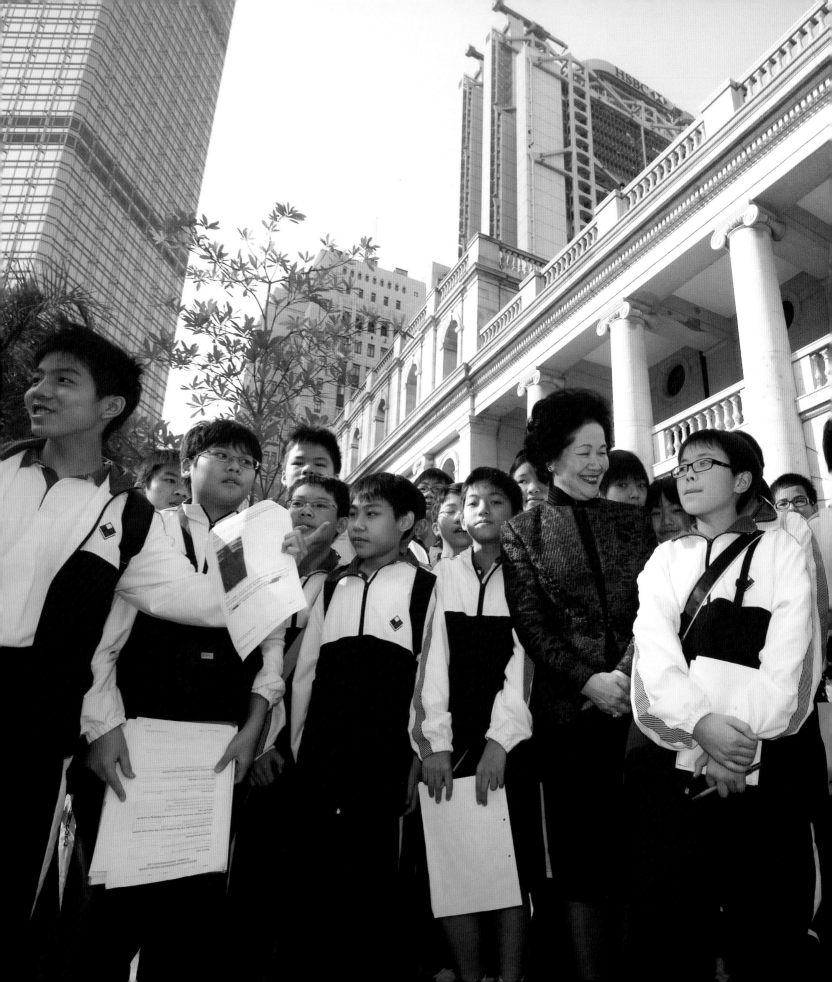

CHAPTER SEVEN

The Conscience of a Country

ANSON CHAN | HONG KONG | NOVEMBER 2006

HONG KONG'S ICONIC SKYSCRAPERS, SOME as high as 88 stories, pull my eyes heavenward, but at ground level, the city's commercial district looks more like a video stuck on fast-forward. Herds of smartly dressed professionals sprint in and out of huge shopping malls. Colorful double-decker buses blare their horns. The noise makes me wince. And everywhere, something is for sale: A roasted duck hangs in a window that also advertises giant sausages. Next door, someone's offering reflexology massage, underwear and mandarin jackets.

Even compared with bustling New York, this packed city is an assault on the senses; yet Anson Chan sits next to me in her big Mercedes-Benz, completely tranquil. Displaying perfect posture and impeccable style, one of the best-known women in Hong Kong surveys her city with the poise of a queen, a dimpled smile softening her aristocratic demeanor.

Left: Anson Chan, one of the most famous women in Hong Kong, chats with students at a government building. Above: A Hong Kong meat company sign, in Chinese.

PHOTOGRAPHS BY CHIEN-MIN CHUNG/GETTY IMAGES

Anson was the highest-ranking woman ever to serve in Hong Kong's government, and arguably its most popular. Until she retired in 2001, she was the city's chief secretary for administration—its second-highest position—and oversaw 190,000 government workers. I must admit: I am wary of politicians. I associate them with compromise. Yet Anson has managed to marry two words that usually don't go hand in hand: *politics* and *incorruptibility*.

During her 39-year tenure as a public servant, Anson gained a reputation for fairness and ethics, and early in her career she even fought for and won equal pay for women in civil service jobs. ("We have proved there is nothing a woman can't do," she says.) Now Anson is leveraging her celebrity to take on the most ambitious work of her life: a campaign for voting rights that has enhanced her standing as "the conscience of Hong Kong." Basically, she's asking a very dangerous political question, and she's repeatedly asking it in public: Will communist China, which rules Hong Kong, allow democracy here?

"I don't believe democracy solves everything, but so far no one has dreamt up a better system," Anson tells me, echoing a famous Winston Churchill quote. That's why,

Above: Workers remove bamboo scaffolding from a billboard. Right: Protesters call for voting rights.

in December 2005, Anson emerged from retirement to march with 250,000 demonstrators demanding universal suffrage in Hong Kong. Last summer she took to the airwaves in a series of radio broadcasts to personally call on residents to join her in another rally—and tens of thousands did. No wonder, then, that everywhere I go with Anson, people stare and wave and ask to shake her hand, offering support and opinions. "I don't have the monopoly on wisdom," she tells me. "A true leader should learn how to listen."

On a map, Hong Kong looks to me like a mere dot in the South China Sea, especially compared with the gigantic Chinese mainland to the north of it. But this metropolis of seven million people is a thriving center for global finance and trade, with a unique history: In 1997, Hong Kong changed nationality overnight. Once a British colony, for the past decade it has been ruled by China under a special arrangement known as "one country, two systems." Although the city is much more open than the rest of China—there's little censorship, and dissidents are not jailed—Hongkongers, as they call themselves, cannot elect their top officials, and they have a genuine fear

Basically, Anson is asking a very dangerous political question: Will communist China allow democracy here?

that eventually Beijing will take away all their freedoms. While Hong Kong's constitution states that residents will someday have complete voting rights, no one knows when—if ever—Beijing will allow that to happen.

One cloudy morning I walk through the campus of Hong Kong University, where Anson studied English literature nearly 50 years ago. I am moved to see a statue entitled *The Pillar of Shame*, honoring the many antigovernment demonstrators killed in Beijing's Tiananmen Square massacre in 1989. That a monument to victims of Chinese oppression could even exist here is a testament to Hong Kong's relative freedom of expression—and a reminder of what Anson is fighting to preserve.

Challenging the Chinese government requires considerable bravery, given its notorious intolerance for those who oppose its views. I ask Anson, a mother of two and a grandmother of four, whether she's concerned that her outspokenness could bring her trouble. "My relationship with Beijing is up-and-down," she says, laughing. "They can't figure me out." Her style is nonconfrontational, but she is also determined to speak the truth. "China," she says, "is dragging its feet on the way to democracy."

You could almost hear the sighs of disappointment across Hong Kong this year as Anson announced she would not run for chief executive, the city's highest position, in elections to be held next March. But Anson says that although residents cast votes for some of their legislators (the rest are selected by special groups), the chief executive is actually chosen by a slate of electors controlled by Beijing. The election's outcome is predetermined—and it wouldn't have been in her favor. So instead of making a futile run for office, Anson formed a group of highly respected community members and former

Left: A Hong Kong housing project. Above left: Mariane with students Nathalie and Nelson; right, inside Nelson's cramped apartment.

"We hear about what happens to democracy fighters on the mainland and we are scared," Nelson says.

"To resist being corrupted by power," Anson says, "you need a strong moral compass. You need to know what matters and stick to it."

One of Hong Kong's crowded markets, where everything you can imagine is bought and sold.

反中歸英 才有希望

我要做皇后

請支持借勢借亂世候選人

1

HK

government officials to put together a proposal calling for universal suffrage. Perhaps no one but Anson, the consummate government insider with first-class political skills, can persuade China to sign on. "I want to create a pragmatic solution that stands at least half a chance of being accepted by Beijing," she says.

Anson's strength to take on such a challenge comes from other strong women in her life. She was born in Shanghai in 1940 to a prominent family. Her father, a textile manufacturer, moved the household to Hong Kong in 1948, one year before China fell to communism. Just two years later, her father died, leaving behind his wife and eight children, including 10-year-old Anson and her twin sister. Anson's mother, Fang Zhaoling, became a successful painter and calligrapher; by the time she died this year at 92, she was one of China's most celebrated modern artists. "My mother," says Anson, "was a Renaissance woman, way ahead of her time. For a young widow of her generation to carve out such a career for herself was remarkable." Anson was also deeply influenced—and partly raised—by her paternal grandmother, an illiterate woman who hobbled about on bound feet, one of imperial China's painful traditions for women. "My grandmother was strict and very strong willed," Anson says. "She is the one who taught me to be upright."

Like any public figure, Anson has her critics. They harp on her well-to-do background and wonder how she can relate to ordinary people when she has never suffered poverty or hunger. So I take a walk in a housing project in the urban Kowloon section to see for myself what people have to say. I find sad, run-down buildings but an animated street life. Old men sitting on the sidewalks play mah-jongg, a gambling game, as little boys run after a soccer ball. I meet a young accounting student named Nathalie and ask for her thoughts on Anson Chan. "She is very strong, and people

Above: At a democracy rally, a demonstrator mocks Anson's ambitions. Right: Anson obliges a fan.

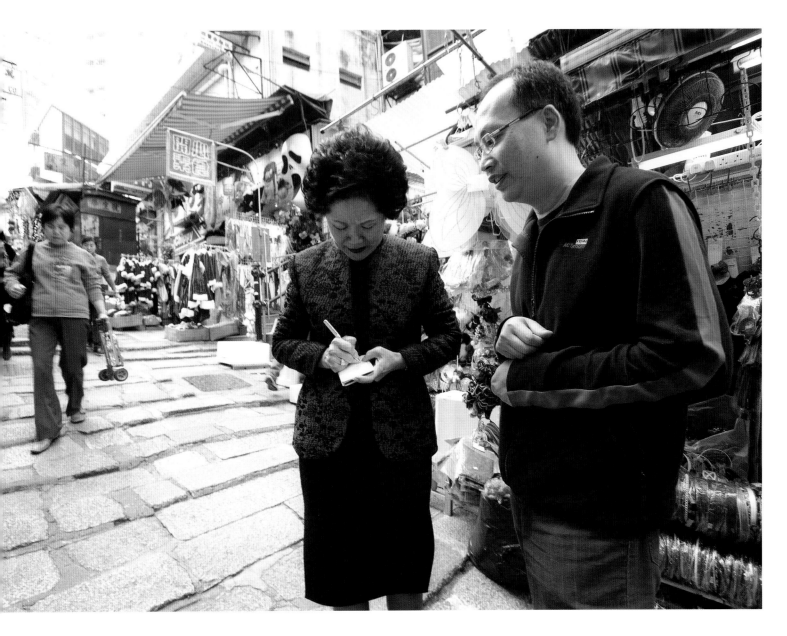

deeply feel for her and trust her," Nathalie tells me. "She makes us feel we are in the hands of a competent, kind, yet strong leader."

Nathalie's boyfriend, Nelson, shows me his apartment, a jammed two-bedroom he shares with three family members. It's depressing and claustrophobic, and I see how little living space there is for the average person in crowded Hong Kong. Nelson tells me that, like many residents, he fears the Chinese government's intentions. "No one knows what China plans for Hong Kong, but we hear about what happens to democracy fighters on the mainland and we are scared," he says. "This is why Anson's fearless stands and honesty are so precious to us."

"Remember what Franklin D. Roosevelt said?" Anson asks. "There is nothing to fear but fear itself."

On my third day in Hong Kong, Anson takes me to her favorite market in the Victoria Peak neighborhood, where she lives with Archie, her husband of 43 years. She gives me a crash course in Chinese food shopping, introducing me to all kinds of exotic ingredients, like a black-skinned chicken used in soups, and a hybrid between an apple and a pear that looks like neither one. Every few steps, we have to stop as admirers gather to talk to Anson. "You do your own shopping?" one woman says, incredulous. Another yells out to her, "You should be chief executive!"

The people gathered in the market clearly love her, and she responds patiently, posing for pictures and signing autographs. Anson is a true leader, and yet she doesn't seem swayed by ego or cynicism—the plagues of politics, as far as I'm concerned. How does she do it? "To resist being corrupted by power," she says, "you need a strong moral compass. You need to know what matters and stick to it."

As we depart the bustling market carrying the frozen lamb that Anson will cook for dinner that night, I share with her another impression: Anyone who stays in Hong Kong has to live with a huge spectrum of fears, which includes crowds, the frantic pace, the heights and, last but not least, the specter of a Chinese crackdown. Her response, delivered in an elegant, almost regal way, is marked by the true revolutionary's balance of pragmatism and idealism. "Remember what Franklin D. Roosevelt said?" Anson asks. "There is nothing to fear but fear itself."

Right: Anson gives Mariane a lesson in Chinese vegetables.

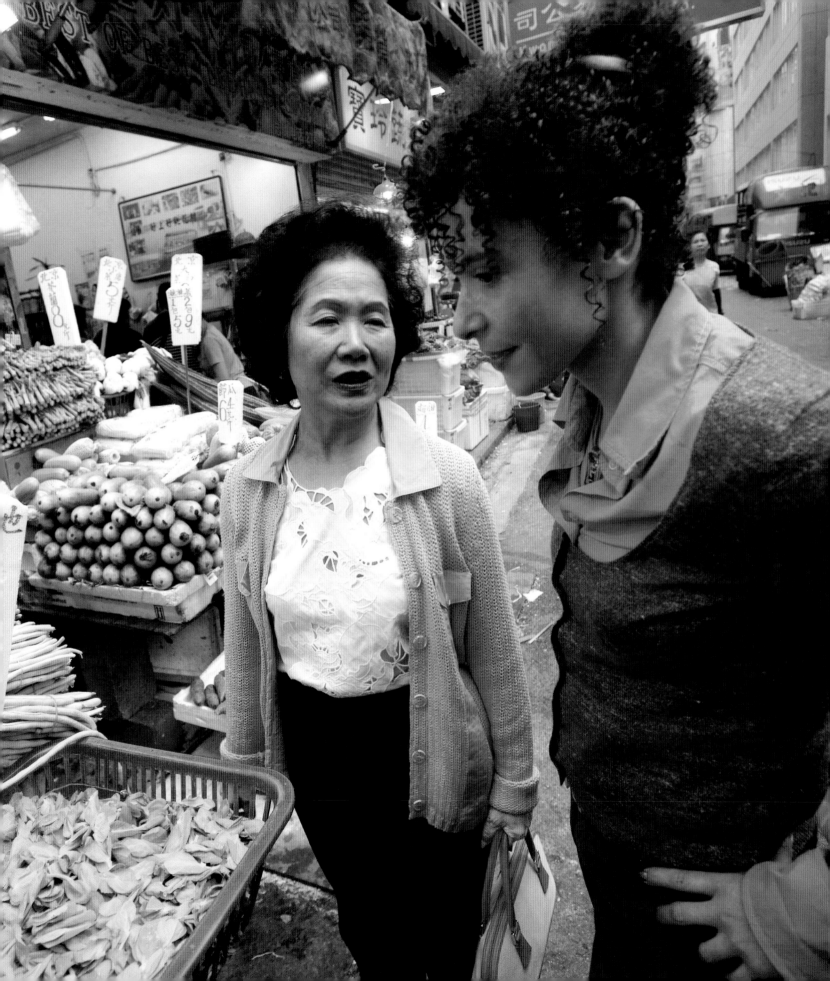

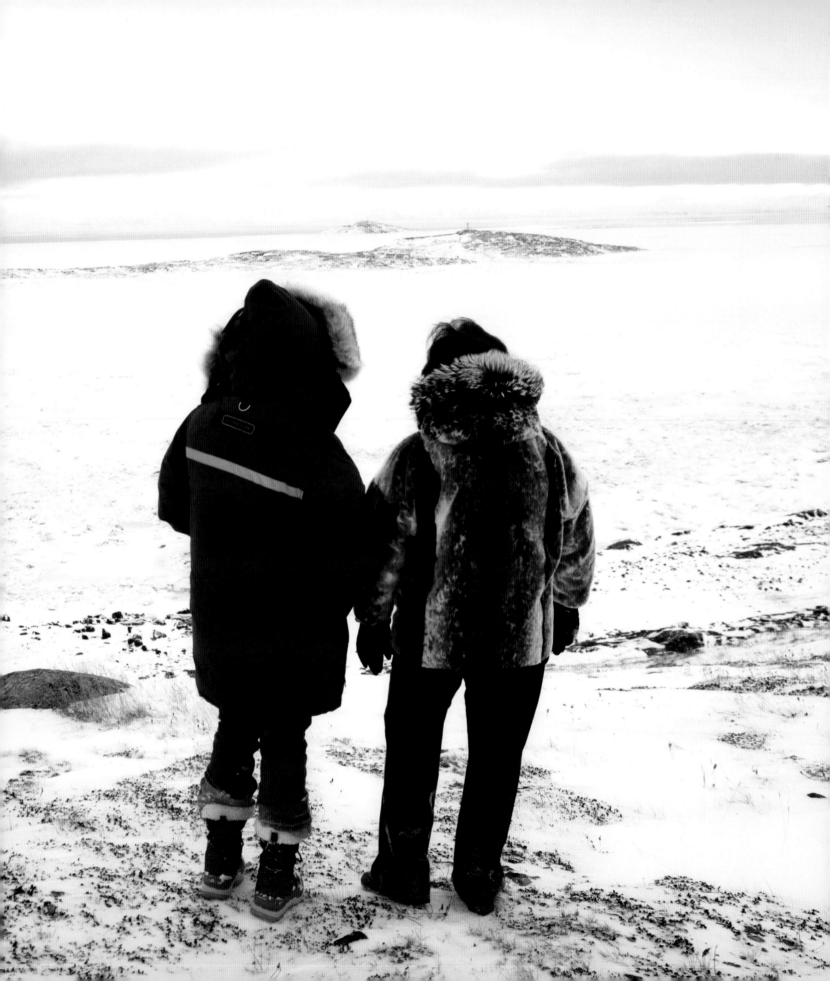

CHAPTER EIGHT

Hope for a Melting World

SHEILA WATT-CLOUTIER | CANADA | DECEMBER 2006

IT'S 2:30 IN THE AFTERNOON, BUT NIGHT is already wrapping itself around the snowy landscape. I am in Iqaluit, a small seaside town on Baffin Island in the Canadian Arctic, almost on top of the world. From the shore, I can see the dark, frigid waters of Frobisher Bay. This is not the way it's supposed to be; I should be staring out at unbroken stretches of thick ice. Although the temperature is below zero and I'm bundled up, struggling to shield my face from the bitter winds, the cold hasn't lasted long enough to freeze the entire bay.

My companion, Iqaluit resident Sheila Watt-Cloutier (I'll use her Inuit name, Siila), 53, is dressed in a sealskin parka and boots. Her hazel eyes survey the scene with the knowingness of someone who was raised in the wilderness. "Look at our world," she tells me. "It is melting away." We are standing on ground zero for global warming.

Left: Mariane and Siila Watt-Cloutier survey the frozen tundra near Iqaluit. Above: A compass from Mariane's travels, inscribed with a Robert Frost poem.

PHOTOGRAPHS BY BENOIT AQUIN/ POLARIS

The warning signs are everywhere. Temperatures are rising at a faster rate here than in other parts of the planet, raising sea levels, eroding the coastline and threatening species—such as the polar bear—with extinction. The Inuit, a community of 155,000 people scattered across northern Alaska, Canada, Greenland and Russia, are also fighting for survival.

"It's so sad," says Sandra. "That was our home. Now it's just water."

Above: Pioneering lawyer Sandra Inutiq. Right: Siila, who demands that the world take action on the climate crisis.

Our deep attachment to the land where we live is an ancestral one; for the Inuit, that primal connection is with the ice. Their way of life—fishing and hunting walrus and seals—depends on it. I have been to many places in the world where epic conflicts are fought over land—the Middle East, for example. But here, one woman is fighting so her land won't disappear. If she doesn't win, she knows her people and their traditions could die off too.

To help me understand how it feels to watch your world vanish, Siila introduces me to Sandra Inutiq, 33, one of her best friends and the first female lawyer in the Canadian territory of Nunavut. Sandra grew up in a remote hunting and fishing camp with her family. But recently the camp just melted away. "It's so sad," she says. "That was our home. Now it's just water."

For the past decade, Siila has demanded that the world pay attention to what's happening to her people. During the four years she spent as chair of the Inuit Circumpolar Conference (ICC), the organization that represents all Inuit, she forced global warming onto the international agenda.

The Arctic is the barometer of the planet, Siila warns. "It's very simple. When the North Pole melts, other parts of the earth flood." I'm reminded of a little girl I met while reporting on the 2000 floods in Bangladesh; she wanted to know where all the water came from. "Are the gods angry at us?" she asked me. Now the "butterfly effect"—the theory that what happens to one part of the planet can directly affect everyone, everywhere—makes perfect sense to me.

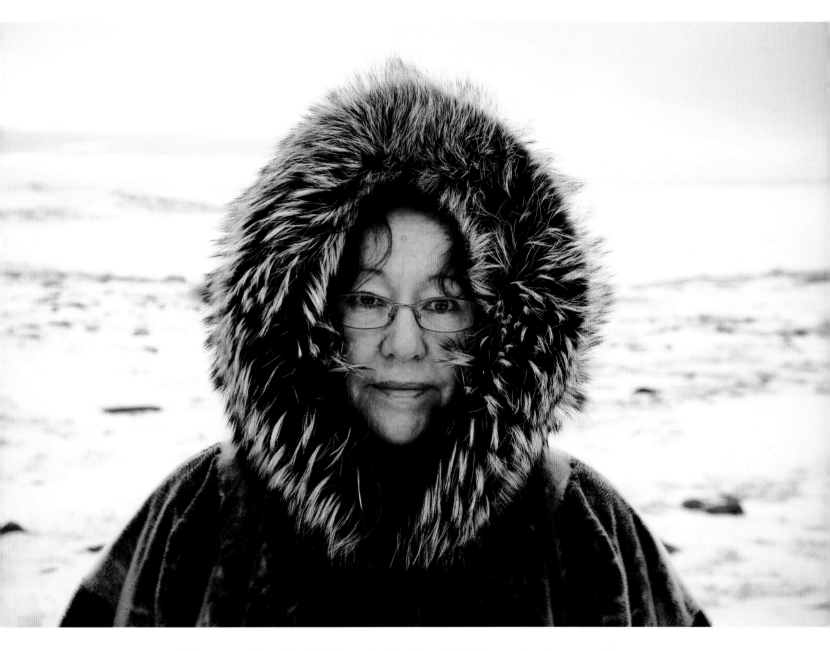

When we walk back to Siila's home in the already dark December afternoon, she suggests we sit in her living room, which has a magnificent view of the bay, without turning the lights on. "This is my source of warmth," she says, pointing at the snowy white immensity outside. With the grace of a cat, she curls up on the sofa, soothed by the stillness. We talk quietly about being women alone, and about the challenge of raising children and keeping our faith. We both use humor as a survival tool; Siila is thoroughly entertained by the sight of me just barely coping with the subzero climate. I playfully remind her that it takes a lot for a Cuban to visit the Arctic in December.

"It's very simple," says Siila. "When the North Pole melts, other parts of the earth flood."

December 2006: Frobisher Bay hasn't fully frozen yet, making ice hunting difficult for the Inuit.

As a child, Siila grew up in true Inuit fashion, fishing and hunt-
ing seals with her family. She nostalgically recalls hearing the crunch of ice under
the dogsled and watching crows circling overhead. "I trusted that my brothers and the
dogs would lead us to the next food source," Siila says. She remembers skinning seals,
cutting up the meat and drinking the blood. To her, hunting is a noble, ancient art.
Hunters share their meat with others in the community and must master skills such as
reading wind direction; analyzing clouds and ice and water conditions; and detecting
polar bears, which also hunt seals and can kill a man with a single paw. "Hunting is at
the very heart of my people's identity and survival," Siila says.

But for years, Siila has watched the Inuit way of life decline. Her region has one
of the highest teen suicide rates in Canada. Domestic violence, incest and substance
abuse are also rampant. "What has happened to my gentle, self-reflective and self-
reliant Inuit hunter?" Siila asks. There are many possible explanations for the Inuit's
troubles; one is the fact that there's less demand for seal skins, partly because of
protests against hunters who club the animals just for their pelts. (Inuit hunters shoot
or harpoon seals and use the whole animal, Siila says.)

Left: Three
generations of Inuit:
Siila, daughter
Sylvia, and grandson
Lee. Above: Iqaluit,
with Frobisher Bay
in the distance.

By far, though, the biggest threat to the Inuit, Siila believes, is global warming. "The depletion of the ice," she says, "is directly responsible for the destruction of our people." For the Inuit, ice means mobility and food—ice means life. Hunters need it to chase seals in their habitat. But warmer weather has shortened the hunting season, forcing the Inuit to pay for pricey imported food. With hunting unreliable, the Inuit future is bleak. The only other jobs in Iqaluit are with the government, and few Inuit are qualified for them.

Siila was raised by her mother and grandmother—both women had children with non-Inuit men who subsequently left them. Siila insists that despite the hardship of being a single parent, neither woman considered herself a victim. "They were survivors," says Siila, who herself is a divorced mother of two. After age 10, Siila attended schools in Nova Scotia, Manitoba and Ontario. "My mother taught me that education provides self-reliance," she tells me.

Later Siila enrolled in an Inuit education course sponsored by McGill University, and also worked as a student counselor with local school boards. That experience furthered her interest in education; she went on to help write a major 1992 report on shortcomings in the school system. That's when she became intimately aware of the desperation plaguing Inuit youth—and decided it was her duty to enter politics. In 1995 she was elected to represent the Canadian Inuit at the ICC, and made saving the Arctic environment her top priority. "I took the flag and started running," Siila says. She launched a campaign against persistent organic pollutants, particles released into the environment during manufacturing. In 2001 Siila persuaded world leaders to support an international ban on these pollutants; it was one of the most quickly ratified treaties in the history of the United Nations.

By the time she was elected international chair of the ICC in 2002, Siila had a reputation for fearlessly forcing governments to confront pollution. She submitted a petition to the Inter-American Commission on Human Rights in 2005, claiming that the United States government was violating Inuit human rights by refusing to cut greenhouse gas emissions. (Yet she praises the American people's efforts to fight global warming.) The month of my visit, Siila received the highest honor her government gives to any citizen, the Order of Canada. She's even been nominated for the Nobel Peace Prize—alongside fellow climate-change crusader Al Gore. Although she's "humbled and thrilled" to be considered for such a prestigious honor, Siila remains focused on her mission. "For me, it's never been about awards but about getting my message out," she says.

Swirling ribbons of green and red unfurl across the endless Arctic sky. They remind me of more powerful forces than my own.

Left: The Northern Lights dance above Iqaluit.

One evening around 9 P.M., after a dinner of caribou meat (still deciding whether I like it), I walk along Iqaluit's nearly deserted streets. I am wearing so many layers of clothes that my body feels far away. Teenagers stand in front of a vacant restaurant, waiting for someone—anyone—to come along and buy their bear-tooth necklaces and other Inuit crafts.

A few minutes into my walk, a celestial show unfolds before my eyes. Swirling ribbons of green and red unfurl across the endless Arctic sky. They are the Northern Lights, which remind me of more powerful forces than my own. I feel like I'm playing a minor part in a major drama.

The next day, the whistling sound of a plane landing at the nearby airstrip brings a smile to Siila's face. Her daughter Sylvia, a 30-year-old beauty with emerald eyes, is home from one of her tours. Sylvia is an acclaimed Inuit throat singer who imitates nature's sounds, such as that of wind, seals or the ocean, using a guttural technique handed down from her elders. She's hopeful that her generation of Inuit will follow in her mother's footsteps and fight to protect their way of life; she's doing her part as an entertainer by teaching young audiences about their traditions. "When the kids sing," Sylvia tells me at Siila's home, "they reconnect to our culture and ancient wisdom, a place of serenity for all Inuit."

Sylvia is also making sure her own child learns to hunt. This past summer, her 11-year-old son, Lee, killed his first bearded seal. Siila proudly points to a photo of Lee with the animal and says, "He is my pride." As Lee rushes past us to play hockey outside with his friends, Siila turns to me. "Time is running out," she says, "but if we reverse global warming, we can still give him back his future as an Inuit."

But this is about all of our futures, really. I came here thinking that I had nothing to do with the melting world, that it wasn't my problem. Siila has taught me differently: We're all connected, to this place and to each other.

Above: Siila drives home in an ice storm. Right: Mariane bundles up against the frigid Arctic air.

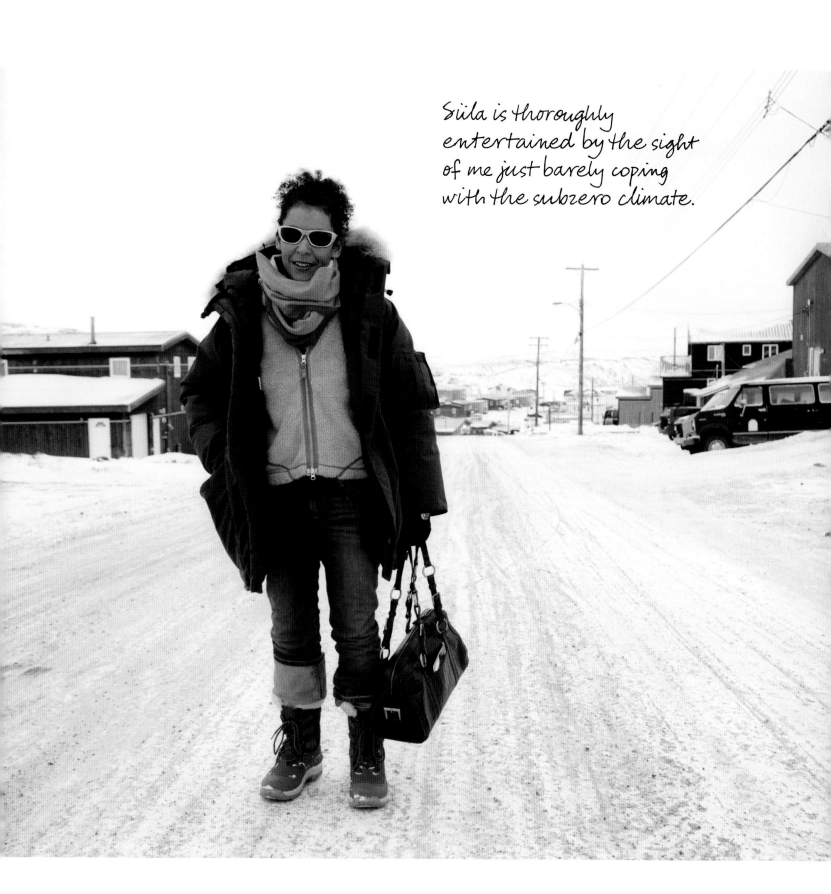

Siila is thoroughly entertained by the sight of me just barely coping with the subzero climate.

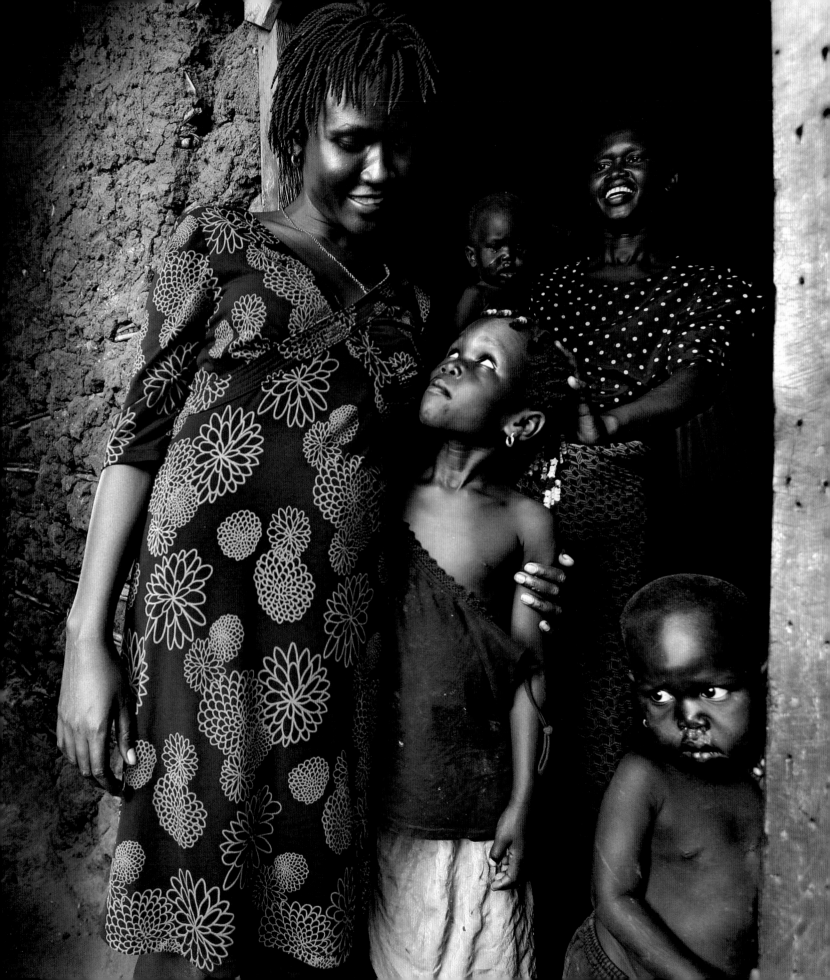

CHAPTER NINE

The AIDS Orphan Turned Healer

JULIAN ATIM | UGANDA | JANUARY 2007

STANDING NEXT TO A HOSPITAL BED COVERED with colorful African fabric, Julian Atim, M.D., gently touches the shoulder of a woman curled up in a fetal position and whispers into her ear. The woman nods without lifting her head, her eyes tightly shut. She is obviously very ill. Looking sad, Julian squeezes her hand and walks away. Across the room, near the door of the Naguru Health Center—a clinic on the outskirts of Kampala, the capital of Uganda—another woman is on all fours in labor, shaking her head back and forth as the contractions tear her up inside. A nurse wearing a white apron and a tiny, old-fashioned cap approaches us with terrible, unexpected news. "The baby is already dead," she says, explaining that the mother had taken traditional herbs to accelerate labor, which apparently killed the fetus. In the delivery room next door, another woman screams with labor pains.

Left: Julian greets Prossy, six, who lives in the Acholi Quarter, a slum near Kampala. Above: An AIDS ribbon is a poignant symbol for Ugandans.

PHOTOGRAPHS BY EVELYN HOCKSTEIN/ POLARIS

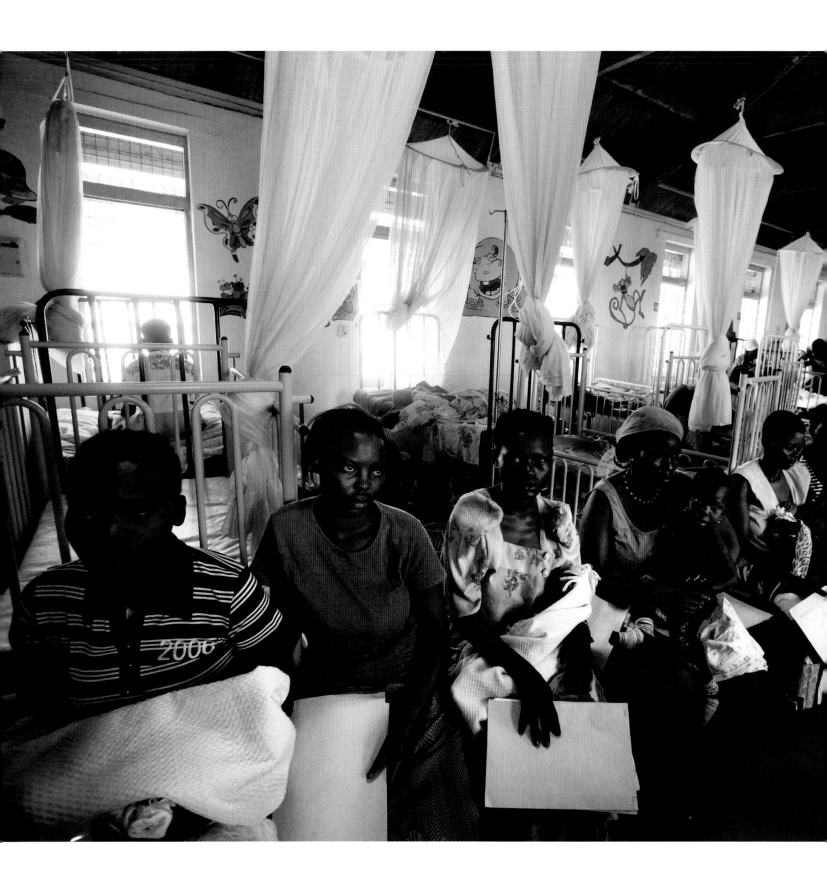

122 Uganda

One mother cries as she gives life, another because she has lost a newborn. In Africa, the line between life and death can be frighteningly fragile.

Julian and I step out of the ward into the clinic's courtyard, where about 100 AIDS patients are waiting to see one of just three doctors on duty. The area is crowded yet strangely quiet: Many of the Ugandans almost whisper when they talk, as if what needs to be said can hardly be spoken aloud. Some patients wait as long as 12 hours to be examined, Julian tells me. "It takes guts to do this," she says, pointing to the overworked doctors.

It does take guts, but caring for Uganda's most vulnerable patients is exactly what Julian, 26, is doing with her life. Kampala could not be more different from Siila's Iqaluit, but Julian is proof that here, too, the power of women is unmistakable. While many of her educated peers have left this country that's been plagued by civil conflict and AIDS for the past 25 years, Julian has vowed to stay and treat all Ugandans. Whether she's working at a clinic in the dangerous, war-torn northern province of Gulu, or volunteering her services at the hospital here in Kampala, Julian's mission is the same: "I want to ensure no life is lost to preventable diseases," she says.

For Julian, the work is deeply personal. She lost both of her parents to AIDS, which has killed an estimated one million Ugandans and has orphaned more than one million children. Just before Julian's mother, Rose, died in 2003, she made her daughter pledge to devote herself to helping others who are less fortunate. "I was always shy, but my mother told me I had to be strong and face the world so that many people's lives could be touched," Julian recalls.

As a doctor, Julian knows all too well that if her mother had been able to afford antiretroviral drugs (ARVs), which can effectively prolong the lives of HIV-positive patients, she would likely be alive today. It's that knowledge, and her promise to her mother, that feed her fierce determination. "Saving others makes me feel better about not being able to help my mother," she says.

Born in Kampala, Julian is the fifth of nine children. Her father, Oryang, was an accountant for the Ugandan military's finance office, and Rose raised the children with the help of two maids. "We lived very comfortably," Julian says. On Sundays, the family would attend church and picnic on the beaches of Lake Victoria, the huge lake that is the main source of the Nile River.

"Saving others makes me feel better about not being able to help my mother," Julian says.

Left: Mothers wait in the crowded pediatric ward of Kampala's Mulago Hospital for doctors to see them and their babies.

In Africa, the line between life and death can be so frighteningly fragile.

In 1986, when Julian was six, tensions were rising in Uganda between northerners and southerners. Her parents, members of the northern Acholi tribe, moved the family to Gulu, thinking the children would be safer there. But within months, violence broke out and antigovernment rebels attacked the family's village. Julian remembers playing with her cousins and hearing gunshots. "We all panicked," Julian says. She hid under a bridge and listened while the rebels marched overhead. "It was my first encounter with fear," she says matter-of-factly. Another day, she says, "I remember waking up one morning and seeing dead bodies lying on the ground." Soon after that, the family fled back to Kampala, but Julian never forgot the tragedy she'd witnessed.

At 13, her life changed again. One day her father suddenly began complaining of headaches; he went to the hospital and never came back. "I didn't realize he died of AIDS until I was in medical school," Julian tells me. Rose was left with nine children to raise—and the gut feeling that she too carried HIV. (Julian says she never knew whether her mother had been tested for the virus, a testament to the stigma attached to it.) The family slowly fell into poverty. Rose started selling cooking oil, milk and sugar on the street, but the family struggled. "We constantly lacked money for food, tuition and clothing," Julian says. "The 10 of us moved into a small, one-bedroom apartment.

Right: Julian comforts a young patient in Kampala.

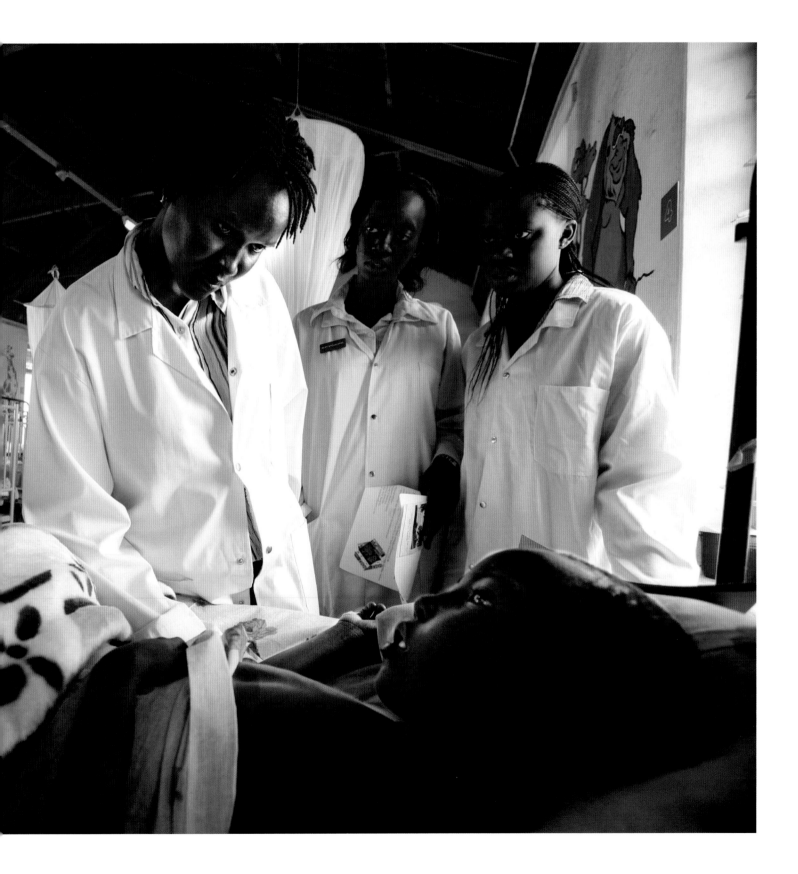

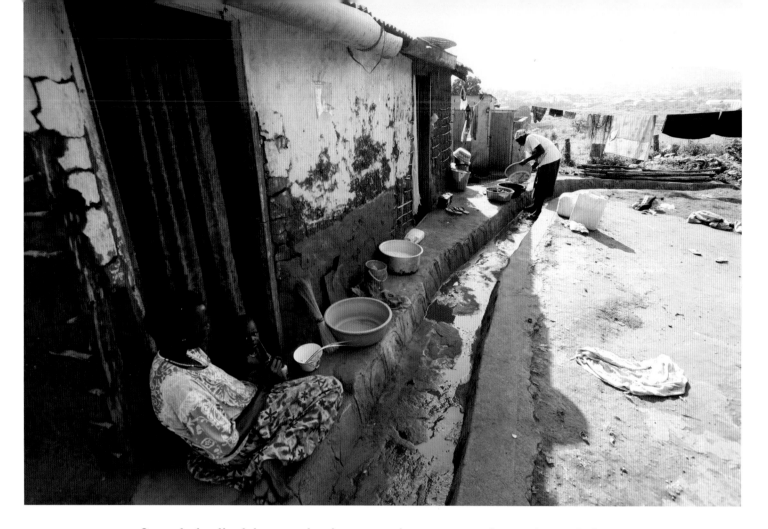

Above: The Kampala slums. Right: Kids at the Aidchild orphanage outside Kampala. One million Ugandan children have lost parents to AIDS.

Once, the landlord threatened to throw us out because my mother was late with the rent—it was the first time I saw my mom cry."

About five years after Julian's father died, her mother began showing symptoms of AIDS. "She would give us little lectures and tell us, 'I will soon be leaving you. You have to take care of each other,'" Julian recalls. Although ARVs were available, they were too costly for most Ugandans. Julian's mother couldn't afford them on top of her younger children's school fees. In the end, Rose performed an astonishing act of motherly love—she put her children's education ahead of her own life.

While her mother slowly declined, Julian was diligently studying on scholarship at Makerere University Medical School in Kampala, where she enrolled right after high school, as is customary in Uganda. "Whenever we studied anything HIV-related, it would make me very sad," she says. "I learned about the medicine my mother needed, and yet I knew she couldn't afford it because her children needed the money to survive." Rose died in January 2003—two weeks before Julian's end-of-semester exams. "Become a doctor and save our people," her mother had instructed Julian—and so she did. Although she was consumed by grief, "my siblings kept me strong by encouraging me to eat, sleep and prepare for my exams," she says. "I passed them all."

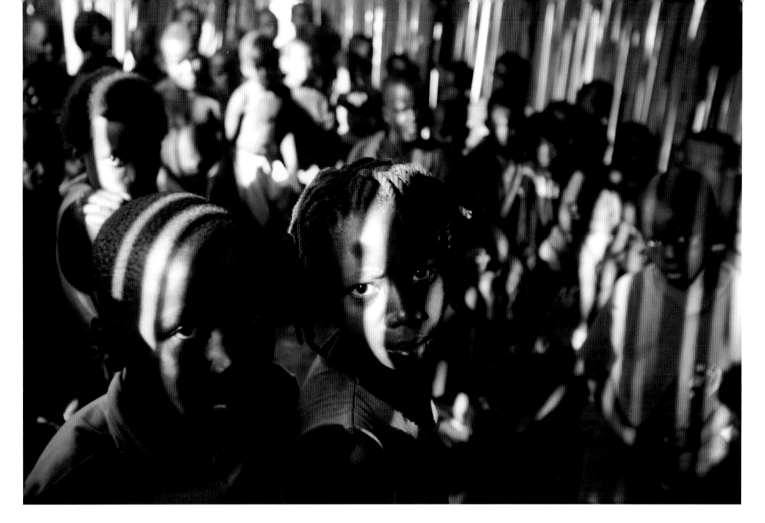

Since her mother's death, Julian has fought to make ARVs more affordable in Uganda. In 2005, while still a medical student, she lobbied the Indian government to maintain its liberal interpretation of drug patent laws, which has made that country the main global source of low-cost, generic AIDS drugs. She also trained young doctors to fight for access to ARVs that could save their lives if they were exposed to HIV/AIDS or other diseases. That work led her to create the Students for Equity in Health Care network, which encourages young doctors to stay in Uganda.

Because her family is Acholi, Julian feels a special responsibility to the people in Gulu, truly among Uganda's most vulnerable.

For her amazing accomplishments, Julian was honored in late 2006 by Physicians for Human Rights, a nonprofit group that campaigns for peace and health around the globe. "Dr. Atim works tirelessly, despite enormous odds," said the group's statement on Julian. "Her story is one of incredible hope, promise, dedication, sacrifice and power." In her practice, she continues crusading; she counsels her impoverished patients about how to get ARVs. Her next goal, she says, is to help women empower themselves economically. "I want to treat the patient as a whole," she says. "My mother died not because she had the disease but because of poverty."

"I understand now that happiness doesn't come from success or money or a man," Julian says. "Happiness means fulfilling my role in this life."

As I drive with Julian through Kampala, I take in the sights outside my window. We pass a little girl with dreadlocks carrying a bucket on her head; behind her is a supermarket called Jesus Cares Food Center. Under the bright sun, a bare-chested man naps while lying on his parked motorcycle—I wonder how he doesn't fall off.

We ride by billboards promoting sexual abstinence. For years, Uganda has been known for its successful anti-HIV campaign, called ABC (for "Abstain, Be Faithful, Use Condoms"). But Julian says the government has recently been focusing on abstinence and fidelity above condom use, and this feels misguided to her; many faithful women get infected by partners who aren't faithful to them, she says. She believes her own dad cheated on her mother and gave her HIV. "I see so many mothers like my own who would never dream of looking at a man she wasn't married to," Julian says. She preaches condom use as the best way to prevent HIV, even among married women.

Some of the most devastating medical cases Julian sees are in Gulu, where she is one of only a few doctors who will brave the region's horrific conditions. Because her family is Acholi, Julian feels a special responsibility to the people there, truly among Uganda's most vulnerable. As a result of nearly three decades of war, AIDS and sexual violence are much more prevalent in Gulu than in the rest of the country. Many women and children Julian treats have been beaten, raped and infected with HIV. Because of the many strong mothers she treats in Gulu who are raising children in unimaginable circumstances, Julian has decided to focus her career on aiding women. "If you save a woman, you know you are saving her children as well," she says. Her efforts in Gulu have also made her realize that her own salvation will come

Left: Julian visits the Acholi Quarter near Kampala.

through her work. "I understand now that happiness doesn't come from success or money or a man," she says. "Happiness means fulfilling my role in this life."

As we travel on a busy road going west out of Kampala, I look back at the city, green and lush with cozy villas perched on hills; from afar, the slums and jammed market streets are invisible. We pass refugee camps where people from the north seek shelter from the ongoing civil unrest. In one camp, I see women working at quarries, hitting stones like prisoners. A few yards away, a preacher screams into a microphone while a crowd of shirtless kids play soccer. We are heading to the Aidchild orphanage, dedicated to kids living with HIV and located about 40 miles west of Kampala.

When we arrive, the children are sitting in class learning their colors.

"Blue is the sky, green is the grass," says a little boy. "And me, what color am I?" a man asks him. "Pink," says the boy, who looks to be about six years old. "You are pink!"

The "pink" man is Nathaniel Dunigan. He is the founder of Aidchild; he arrived here from the United States nine years ago. "All I wanted," he says, laughing, "was a safari." Instead he saw countless children orphaned by AIDS or other deadly diseases living in the streets alone, hungry and scared. When Nathaniel went back home to Arizona, he organized a yard sale, made $3,500, and used the money to build the orphanage that now shelters 70 children—from ages six months to 15 years—all HIV-positive.

The children here look happy and healthy, a welcome contrast to the kids I met in Kampala. In the city there was little Natalia, who suffered from heart disease and had the swollen belly often seen in malnourished children, and Simon, who could hardly breathe due to respiratory infection, and many others whose names I never learned but who looked like they had suffered more than they could bear.

"If you save a woman, you know you are saving her children as well," says Julian.

Above left: Mariane interviews children at the Aidchild orphanage; right: time for a swing. Opposite: Julian visits some of the orphans.

Julian sits on the beautifully maintained lawn, where she's joined by a boy named Peter, who was born with HIV and has suffered every possible abuse, and his friend Marvin, who was found at the gates of the orphanage. "I know what you feel," Julian says to them. "I am a doctor but I am also an AIDS orphan. That's what I came here to tell you." Looking at the expressions on the faces of these boys, it's obvious to me that Julian's words open a world of possibilities to them. Surely neither one has ever dreamed about a hopeful future in which he, too, could grow up healthy and save people's lives.

On our trip back to Kampala, tragedy strikes: A child who couldn't be more than eight years old is hit by a car in front of us. We stop to offer help, but the child is lifeless, his eyes wide open. It's a moment of sheer horror. Alive one second, dead the next. Julian and I remain silent the rest of the way. The child has died; there is nothing to say.

Julian's mother performed an astonishing act of motherly love—she put her children's education ahead of her own life.

Later that night, Julian takes me to the home she shares with her four younger brothers and sisters in Kampala. She cares for her siblings and teaches them about HIV prevention, she says. Julian shows me a small memorial she built for her parents: yellow candles surrounding a photograph of the couple, wreathed with a small AIDS ribbon. In the soft candlelight, our little group joins hands and prays together. Our photographer is a young Jewish woman; I am a Buddhist; Julian's family are all Christians. Yet the prayers on our lips and hearts are the same: We pray for courage.

And when I look more closely at the image of Julian's mother, I do not see a victim; I see an unsung hero—a brilliant example of what human dignity can achieve. She preferred to die rather than let ignorance stunt the lives of her children. Like the daughter she left us, few people deserve more respect.

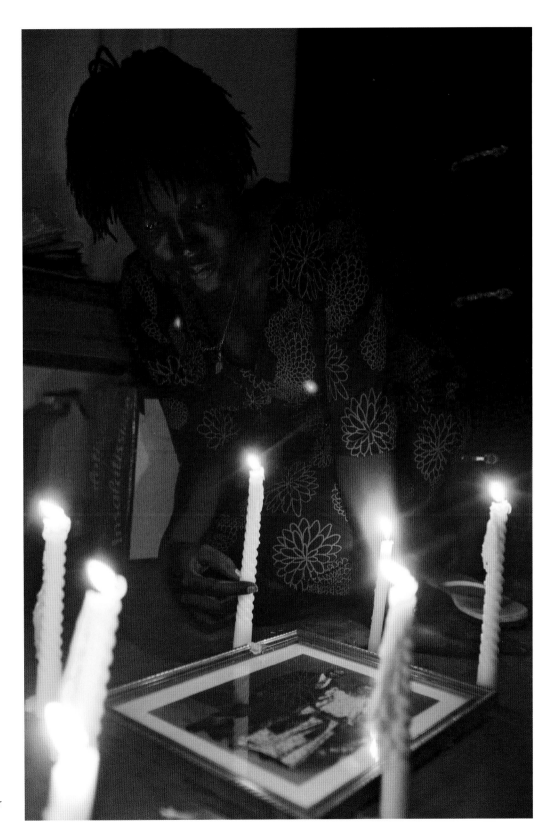

Left: Mariane meets
Acholi residents
of Kampala. Right:
Julian remembers her
parents.

Giving Outcast Moms a Future

AICHA ECH-CHENNA | MOROCCO | FEBRUARY 2007

I AM SITTING BY THE ATLANTIC OCEAN FACING

Casablanca's Mosque Hassan II, named for the Moroccan king who died in 1999. From the mosque's tower—the world's tallest minaret—a laser beam shining toward Mecca can be seen for miles. I'm here with Aicha Ech-Chenna, the first vocal advocate for Arab women I've met so far in my journey, whom some call "the Mother Teresa of Morocco." Aicha and I share a powerful history: Both our lives have been deeply affected by Islamic extremism. She has spent decades fighting for the rights of unwed mothers, who are pariahs in Muslim society; for this, a few religious fanatics have threatened to stone her to death. Ironically, the same kind of people made me a widow and a single mom.

Left: Aicha, "the Mother Teresa of Morocco," with Mariane at Casablanca's Mosque Hassan II. Above: A Moroccan Coke bottle.

PHOTOGRAPHS BY TARA TODRAS-WHITEHILL

"What is your son's name?" Aicha asks warmly, squeezing my hand and searching my face with her large brown eyes. I tell her my husband chose to call our baby Adam after the first man in the Bible, the Torah and the Koran. "Adam, of course," she says, tears shining in her deep brown eyes. Suddenly a call to prayer bursts from the minaret above us, and it seems like it's coming from the heavens themselves. Aicha turns her palms skyward as if to call her God to look upon the painful realities of our world.

Here in Casablanca, the modern and the traditional mingle in crowded, dynamic streets. College students in trendy clothes carry Esprit shopping bags alongside women covered from head to toe in dark fabric. Most roofs sport satellite dishes, like a jungle of giant metallic ears, even though poverty abounds and nearly half of all adults are illiterate. Morocco is considered a progressive Muslim country, and its king, Mohammed VI, is an ally of the United States. But even here, Islamic fundamentalism is still pervasive.

Perhaps no group feels the heavy, cruel hand of extremism as deeply as unwed mothers. Because extramarital sex is the ultimate cultural taboo—a

"Single mothers are considered prostitutes here," Aicha tells me. "They are invisible."

crime punishable by imprisonment, although it's rarely prosecuted—unmarried mothers are ostracized, harassed and even threatened with death by their own families. (So-called honor killings are illegal and rare in Morocco, but they do occur, usually in rural areas.) "Single mothers are considered prostitutes here," Aicha tells me. "They are invisible." Even if a woman becomes pregnant from rape or incest, she and her baby are shunned by society, like an ocean rejecting waste.

To avoid the stigma, many mothers abandon their newborns anywhere they can—sometimes in garbage bins, or in public parks, or in whatever hidden spot they've found to give birth in. I know that if I were to abandon my child in such a way, I would live thereafter as a zombie: alive but dead inside.

Most of Morocco's unwed mothers are poor, illiterate women from the countryside who started working as domestic servants, or "little maids," as young as age seven, explains Aicha. Handed over into virtual enslavement by their families,

Left: Contrasts abound in Casablanca. Right: The city is a major Atlantic port.

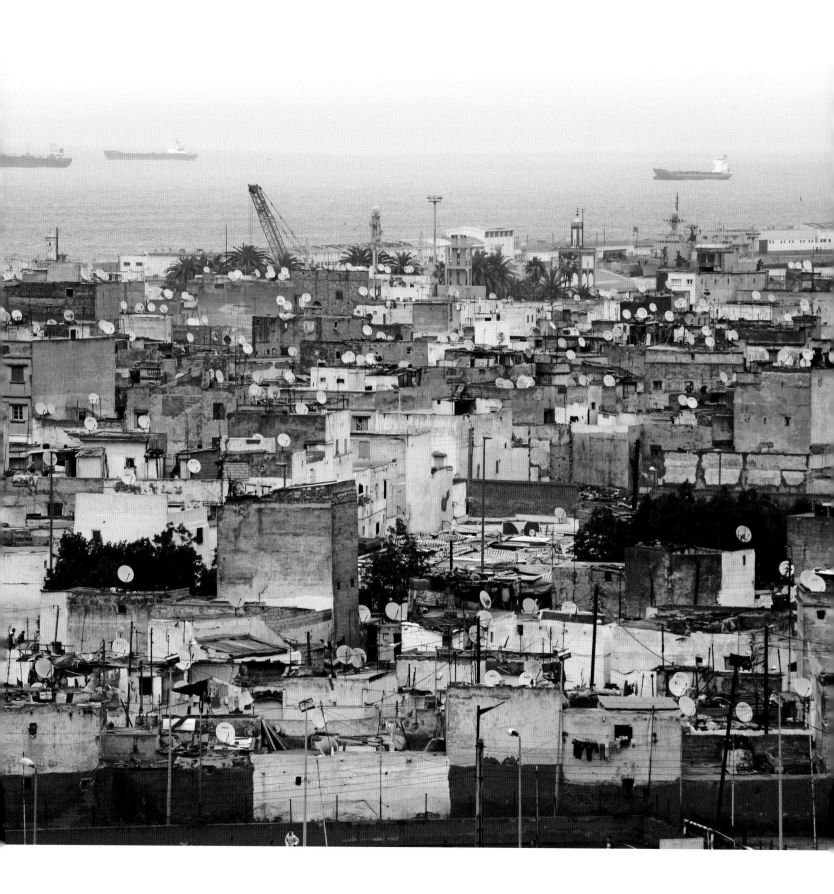

Morocco is considered a progressive Muslim country. But even here, Islamic fundamentalism is still pervasive.

Muslim worshippers
gather at
Casablanca's
Mosque Hassan II.

Unmarried mothers are ostracized and even threatened with death by their own families.

the girls spend long hours cooking and cleaning for better-off Moroccans. Their fathers take what little money they make. After years of this, many girls will have sex with any man who promises marriage; countless others are raped. Those who get pregnant often end up on the streets—and worse. "These girls are at risk of being beaten and even killed," Aicha says.

Aicha, 65, found her calling after meeting a frightened young woman who haunts her to this day. It was 1980, and the woman came to abandon her infant at the public health office where Aicha was employed as a social worker. As a nurse took the child away, "she pulled the baby off his mother's breast and milk splashed all over his little face," Aicha recalls. Disturbed by that image, she couldn't sleep that night. "I kept thinking that the mother needed to nourish her child, but she was too afraid to keep him," says Aicha, who has been married for 40 years and has four children of her own. Not long afterward, she rented a basement office and set up a social work practice just for desperate unmarried young mothers, something no one had ever done.

Soon enough, women sought out Aicha with their tragic stories. One pregnant girl was told by her mother, "Go empty your stomach; then you may come back." There were girls impregnated by their own fathers or brothers, "the most broken of them all," says Aicha. She met one girl who wore gaudy makeup, even though she knew people might

Opposite: A single mother with her young son. Above: Unwed mothers at Solidarity Feminine learn skills like hairdressing.

mistake her for a prostitute. She told Aicha, "I wear colors to prove that I exist, that I am a real person."

In 1985, Aicha and a cofounder expanded on her groundbreaking work by starting Solidarity Feminine, the first organization in Morocco dedicated to helping unwed mothers keep and support their babies. To give women job skills, Aicha opened a restaurant in Casablanca and hired 11 single mothers as its staff. Today Solidarity Feminine employs about 60 unwed mothers at two restaurants and a bakery and provides them with education, child care and health care. The women earn enough to rent their own apartments for about 1,000 dirhams, or $120, a month. Although women usually stay in Aicha's program for three years, some leave sooner for better-paying jobs. "We help them live with dignity," says Aicha.

Aicha's group also provides about 500 unwed mothers a year with much-needed legal aid. A major hurdle for many women is obtaining last names for their babies. In the Arab world, women lack authority to give their newborns a surname; they must ask permission from their fathers or husbands. Without a last name, children cannot get government IDs or attend school—it's as if they'd never been born. Aicha's staff convinces reluctant, often angry, men to pass on their names to grandchildren they didn't know existed. "We politely negotiate with them," she says. Many of Aicha's clients

Above left: Mealtime at Aicha's center; right: clay tajines at Solidarity Feminine's restaurant. Opposite: Sharing a bed in a cramped Casablanca apartment.

also lack IDs because they, too, were born to single women; Aicha helps them get their official paperwork so they can work legally and receive government benefits. Although I am a widow, I am a single mother, too, and the possibility that my identity, or my son's, would be erased because of that simple fact is unfathomable to me.

In Solidarity's tiled kitchen, Khadidja's hands are dark with coal as she prepares the fire to make a tajine, a traditional dish cooked in a clay pot, for one of the group's restaurants. Behind her, five girls with cloth-covered hair prepare bread and rice. The only sounds are those of birds, and babies crying in the nursery on the other side of the kitchen.

Outside, two Solidarity mothers sit with their toddlers. The women's names are Badia and Samira, and I'm told that they have been acting rebellious lately. That night I visit them at home. Badia brings me to the four-room apartment she shares with eight other women and their babies. She shows me her 100-square-foot room, for which she pays 50 dirhams, or $6, a week. It has two mattresses, two tin plates and a table with a can of oil. There's no food in sight.

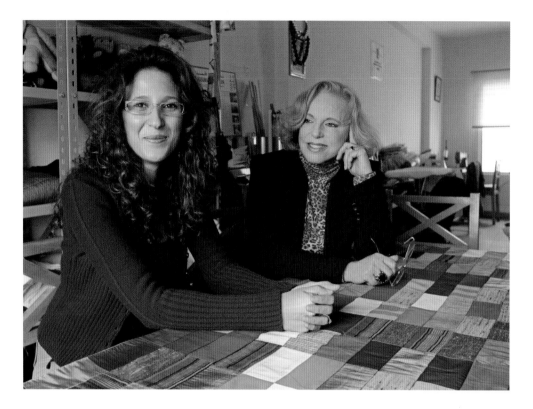

Badia has a lovely face but her eyes flash with rage. As her 18-month-old boy, Ryan, begins to whine softly, Badia slaps him in the face. "We know nothing but humiliation," Badia says, so blinded by her own pain that she does not realize she's passing its legacy on to her child. "It's killing us, and we can't help but take it out on our kids." Badia explains that she is verbally assaulted whenever she walks down the street. (Single moms are routinely harassed in public, according to Aicha. "They can be identified because they aren't with a man," she says.) Ryan looks at me, and I can't find even curiosity in those sad little eyes; already, it seems, the light in them has gone out. I wonder what sins these women and babies are being punished for, but thanks to Aicha, they still have each other to hold on to.

Aicha has faced great dangers in her work. In 2000, an extremist imam issued a fatwa, or religious ruling, calling for her to be stoned to death. "I'm not afraid," she says, "because I've done nothing wrong." Soon after, she gave an unprecedented interview to Al Jazeera denouncing the stigma on unwed motherhood. She hit a nerve. "People called me from all over the country agreeing, saying I couldn't let the Islamists win," she says. More astonishing, the king summoned her to his palace and awarded her the Medal of Honor. "Please don't give up," he told her.

Perhaps Aicha's greatest achievement has been to inspire a new generation of women activists. I meet Nabila Tbeur, 34, who works for INSAF (National Institute for

Above: Nabila Tbeur and Mériem Othmani, the president of INSAF, a group that assists unwed mothers. Right: Babies born to "outcast" moms sleep in INSAF's nursery.

Distressed Women), another Casablanca group that helps unwed moms get job training, child care and health benefits. Nabila explains that single motherhood is not just a problem of poverty; even educated, affluent women are affected. "The shame attached to sex outside marriage runs deeper than the blood in our veins," she says. I meet Zoulikha, a young mother who wears a veil with jeans and sneakers as she types on a computer. Her baby, Youssef, is just three weeks old. Zoulikha, 22, was an unmarried college student when she got pregnant. Now, she says, "I'll keep my baby and go back to school, *insha'allah* [God willing]."

Today, at peace with her God and her king, Aicha finds strength in knowing that others, like Nabila, are fighting alongside her. In her struggle for the dignity of all mothers and children, Aicha has displayed true faith; she's proof that an individual with determination and courage can win against those who advocate blind hatred. On the morning of my departure, we see each other one last time, mostly to hug. Aicha tells me to hug Adam for her too. Then she shakes her head and says, "I can't believe you are a single mother. May Allah bless your husband and son. May He bless your soul."

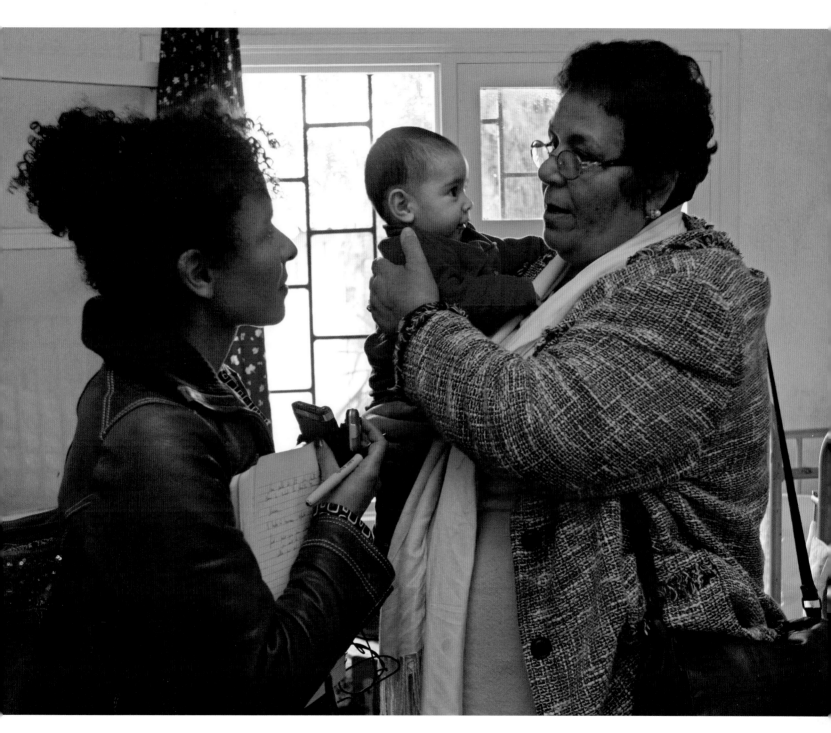

Left: Nap time at
the INSAF nursery.
Above: Mariane talks
with Aicha, who
is holding a single
mother's child.

A Child of War, Building Peace

MAYERLY SANCHEZ | COLOMBIA | MARCH 2007

HOLDING OPEN THE FADED CURTAIN THAT isolates him from the world, a six-year-old boy stares out the window, his forehead pressed against the glass, the heat of his skin creating a butterfly-shaped cloud. Across the street, his neighbor, Mayerly Sanchez, 23, the youngest woman I've visited in this year of traveling, waves at him. Smiling sadly, the boy drops the curtain and disappears. Here in Soacha, a poor, high-crime suburb outside Bogotá, schools are so crowded that students attend classes for half days only, if at all. When they aren't in school, many—like the boy in the window—stay locked inside by parents who fear they'll be harmed if they play outdoors.

Mayerly picks up a naked, broken doll from the gutter and gently sets it on the sidewalk. Around us, the air smells of marijuana, cooking oil and car fumes. We're standing in front of the house where Mayerly's

Left: Mayerly Sanchez leads a children's "peace meeting." Above: 10,000 Colombian pesos—roughly the equivalent of $5 U.S.

PHOTOGRAPHS BY DAVID ROCHKIND/ POLARIS

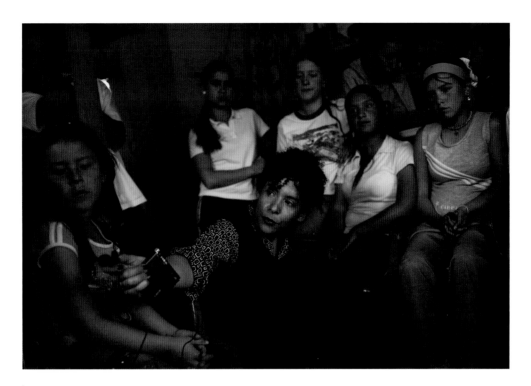

best friend, Milton, once lived. Eleven years ago, 15-year-old Milton was stabbed to death around the corner from his home—another victim of Soacha's rampant violence. "So many friends were being killed for such insignificant reasons," Mayerly tells me in Spanish.

Ironically, before Milton died, he and Mayerly were working to end violence in their community—a mission she eventually helped to take nationwide. Now Mayerly is a leader of the Children's Movement for Peace in Colombia, a group that has been nominated four times for the Nobel Peace Prize. "Everyone uses the *peace* word, from presidents to beauty queens," she says, her warm smile surrounded by deep dimples, her face sprinkled with tiny freckles. "But people forget there is nowhere to start but yourself."

For more than 40 years, civil conflict has battered Colombia. Leftist guerrillas and right-wing paramilitaries, fighting one another and the government, have taken turns waging campaigns of terror. Amid the chaos, drug cartels and criminal gangs have flourished, and the resulting instability and poverty have contributed to widespread domestic violence. Millions of people have been displaced, and tens of thousands kidnapped, assaulted or killed.

In the 1990s, tired of the death all around them and the abuse many of their friends were experiencing at home, Milton, Mayerly and a few others took action. With help from World Vision, an international aid organization, they started a children's peace club. Their goal was to keep kids they knew away from crime and drugs and safe from

Left: Milton's mother visits his grave. Above: Mariane interviews kids at a peace meeting.

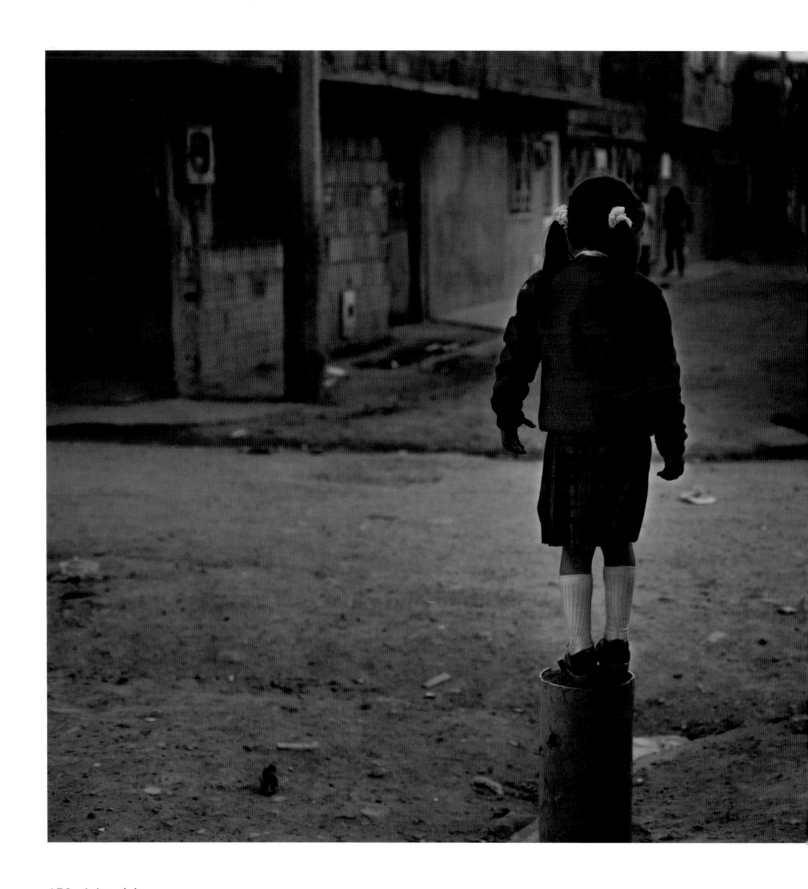

domestic abuse. "We wanted to generate peace, starting with ourselves and our families," Mayerly says. The kids met in a desolate park in a Soacha neighborhood called Cagua, near a quarry where child laborers worked for a few cents a day. They began with "conversation contests," in which players were disqualified for insulting each other; then they persuaded some gang members to join their soccer games, and even put on plays about tolerance and courage. "We planted the seeds and watched them grow," Mayerly says.

Soon their club had two dozen little peacemakers. Recruiting members wasn't easy, Mayerly recalls: "If a kid's mother was murdered, how do you talk to him about peace?" But even those most affected by crime were open to her message. "Unlike adults, children still have hope," she says. Just a child herself, Mayerly was a true leader. "Kids would knock on my door and ask when the next peace meeting was," she tells me. "For some, it was all they had."

In 1996, the year Milton died, 12-year-old Mayerly was invited to a national UNICEF workshop for 25 child leaders from all over Colombia to strategize about spreading peace across the country. From that meeting, the Children's Movement for Peace was born. Its first goal was to plan a countrywide children's "vote" to give kids ages seven to 18 a chance to assert their rights and tell adults what kind of country they wanted to live in. The organizers received death threats, Mayerly says, but continued their get-out-the-vote campaign anyway. "They can kill some of us," she remembers thinking, "but they can't kill us all." On October 25, 1996, close to three million kids went to public places like

"Unlike adults, children still have hope," says Mayerly.

Left: For Bogotá's youngest, overcrowded schools and dangerous streets are everyday concerns.

schools and churches and, using pencils and paper ballots, voted overwhelmingly for their right to peace, among other issues. Many children wore their best clothes and carried flowers to the polls. "It was a day of celebration," Mayerly recalls.

For the first time in decades, almost all violence ceased on a voting day. The kids' action wasn't just symbolic. The following year, 10 million adult Colombians voted to support the children's referendum and demand an end to war. In 1998, President Andrés Pastrana came to power on a peace platform, and the government and guerrilla groups held unprecedented talks; although fighting resumed, the summits signaled progress. That same year, the Children's Movement for Peace, with Mayerly as one of the leaders, was nominated for the Nobel Peace Prize. It was the first of four consecutive nominations, and the first ever for children.

Today violence still plagues Colombia. But nearly 100,000 children are now part of Mayerly's movement. Among the kids' achievements so far: getting the Colombian government to stop recruiting boys younger than 18 for mandatory military service, and helping to increase the number of kids in school, especially girls. "Young people

Above: A picture drawn for Mariane by Mayerly's little sister, Natalia. Right: Milton's niece (and Mayerly's next-door neighbor), five-year-old Ashly Camelo.

> *"Everyone uses the peace word,"* Mayerly says. *"But people forget there is nowhere to start but yourself."*

are still trying to solve the problems that adults created," Mayerly says.

In the slums of Cagua, homes are made of broken pieces of wood, cardboard and corrugated metal. They have no running water. To me, the adults here look 20 years older than they are, and the children much younger. Mayerly and I have come to see Esperanza, an 11-year-old who looks six, her teeth rotten or missing. When Esperanza spies us, her little face breaks into a heart-warming smile. Turned away from the overcrowded school system, she stays home and looks forward to visits from her mentor, Mayerly. "Tolerance is about self-control," says Esperanza, proud of her wisdom. Lifting hair out of Esperanza's dirty face, Mayerly says, "People think kids are the future, but really they are the present."

Mayerly now trains children to follow her example in an endless chain of solidarity. I accompany her to a peace movement meeting of about 20 kids in what looks like an abandoned grocery store. Atop their list of concerns is graffiti found nearby that said, "Good kids go to sleep early, and we put bad kids to sleep ourselves." Laura, 14, explains the menacing message: "That's how gangs announce there will be a 'cleaning,' when they shoot whoever is on the streets."

Despite the danger in their lives, the children are eager to share what they've learned. "It is easier to promote peace when children are talking to children," explains Christina, a precocious seven-year-old. "You have to apply what you preach to your own life." Mugged recently by a group of knife-wielding 10-year-olds, 14-year-old Felipe explains why he didn't fight back: "[The muggers] left me believing that answering violence with more violence is useless." We know this is true, but these children have the heart to keep spreading the message; if only the world would listen.

As I drive through Bogotá's outskirts, I think of all the child casualties of war I have met during my years as a journalist. The idealism of Colombia's young souls contrasts with my memories of hopeless kids whose dreams were derailed by violence. I pass a mural with crude lettering that reads: "Truly free men build their own freedom."

Right: The streets of Soacha, where crime and mayhem have been facts of life for decades.

The ultimate weakness of violence is that it is a descending spiral, begetting the very thing it seeks to destroy. Instead of diminishing evil, it multiplies it ... Through violence you may murder the hater but you do not murder hate. In fact, violence merely increases hate ... Returning Violence for Violence multiplies Violence, adding deeper darkness to a night already devoid of stars.

(Where do we go from here Chaos or Community)

"Returning violence for violence multiplies violence," reads the poem, "adding deeper darkness to a night already devoid of stars."

At the Soacha home Mayerly shares with her mother and two sisters, I cook a Cuban ground-beef dish called picadillo—the only item in my culinary repertoire—and Mayerly tells me about the most difficult time in her life. In December 2003, she was leading a peace meeting in a town hours away when a call came: Her father had been killed by a hit-and-run driver. Mayerly's family didn't have money for funeral home fees, so her father's body had been left lying on the street until relatives could pick it up. The driver was never identified. Filled with anger, Mayerly questioned her work. "How can I teach kids about justice when there is none?" she wondered.

Mayerly, who was attending college on a scholarship, began working part-time for World Vision to pay her family's bills. Yet while she tried to focus on her job, numbness enveloped her. At a peace meeting held soon after her father died, she forced herself to listen as a sobbing boy described how his father raped him at night. Mayerly cried with him; she because she'd loved her dad, he because he hated his. "I understood then that I couldn't stop my work," she recalls. "I will be there for these kids until I die."

Mayerly graduated from college in October 2006 and now travels to poor communities throughout Colombia, teaching kids how to try to live free from abuse and violence.

Left: A poem written by a child in Mayerly's group. Right: Mayerly and her sister, Natalia.

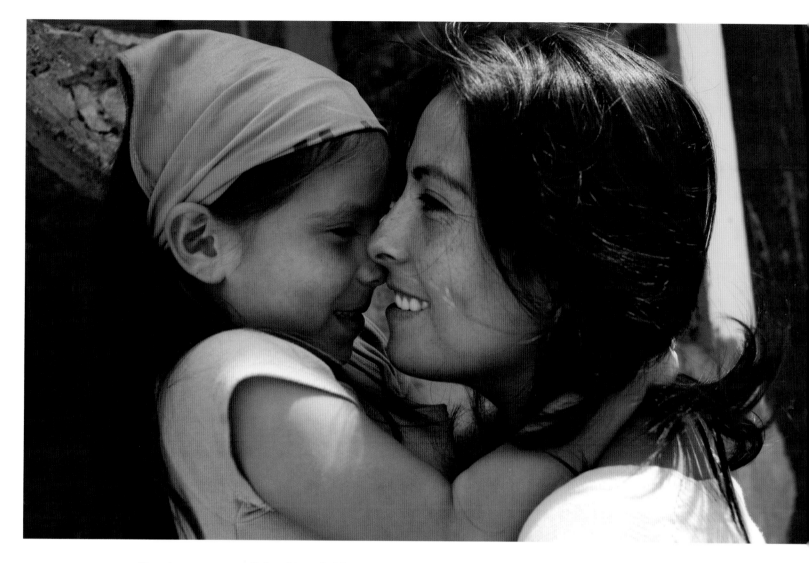

She also represents Colombian children in a government-run program that seeks to rid the country of land mines. "I want to give them hope," she says. Her dream is to take the children's peace movement worldwide.

On the last day of my visit, I go to the local cemetery where Milton's ashes are kept. Mayerly brings flowers while her younger sister Natalia, now six, dances between the tombs. The child picks up a purple dahlia from the ground. "Come here, you little troublemaker," Mayerly calls after her affectionately. But Natalia turns as if stung by a bee, her hair flowing in the chilly wind.

"Not troublemaker," she says, with authority. "Peace. I am a peacemaker."

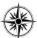

A Woman, an Island, a Triumph

NILDA MEDINA | PUERTO RICO | APRIL 2007

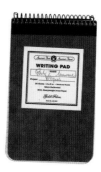

VIEQUES IS A NARROW, 21-MILE-LONG ISLAND that is part of the territory of Puerto Rico. With peaceful white-sand beaches surrounded by aquamarine waters, and no glitzy casinos or monster resorts yet, Vieques—quite a change from Bogotá's dusty slums—is often described in tourism brochures as the last unspoiled Caribbean paradise with one of the finest bioluminescent bays in the world.

Until recently, though, Vieques wasn't considered a desirable vacation spot. During World War II, the U.S. military expropriated three-quarters of the island, forcing residents—simple farmers and fishermen, mainly—to leave their homes and relocate in the middle of the island so it could begin testing weapons here. By the time the military pulled out in 2003, 18,000 tons of explosives, some containing napalm and Agent Orange, had been detonated. It's no wonder the Vieques economy has long been abysmal; who would want to invest in such a place?

Left: Activist Nilda Medina, outside the former Vieques naval training range. (The sign reads, "Enough! No more bombs!") Above: Mariane's notes from Vieques.

PHOTOGRAPHS BY JOSE JIMENEZ-TIRADO/POLARIS

> "We've made so much progress," Nilda tells me, "but the horizon is still far away."

Everything moves slowly on Vieques—it's the phenomenon called "island time." When I jump into a taxi for what should be a five-minute ride, the driver, nicknamed Coqui after a frog found in the region, stops to buy himself dinner, which is a plastic bag of ghastly-looking seafood. Then he buys lottery tickets and chats leisurely with the ticket seller.

A half hour later, we reach my destination—a meeting with a woman named Nilda Medina, who played no small part in getting the military out of Vieques.

In her demeanor and history, Nilda reminds me of the legendary civil rights activist Rosa Parks. Both are so-called ordinary women who made simple decisions that changed their worlds. Rosa, an African American from the segregated South, uttered arguably the most famous "no" in history when refusing to give her bus seat to a white man in 1955; that bold act launched the modern civil rights movement. Nilda, a Vieques resident, had her Rosa Parks moment when she decided she would no longer step aside to let the occupying war machines go by; thanks to her persistence and that of her countrymen, they finally went away.

I wanted to see what's been happening on Nilda's island since bombs stopped falling on it, and now we sit together in rocking chairs on her front porch, looking out at the Caribbean Sea. Here, Nilda reflects on the nearly 30 years she has dedicated to Vieques—and the many struggles still ahead as residents fight to clean up the toxic mess left by the military, find good jobs and give their young people hope. As we talk about the island's difficult past and uncertain future, Nilda's earnest, round face and long, braided hair glow softly in the spring sunset's orange light. It's surreal to talk to a woman who looks so peaceful and sweet about bombs and killing machines, but she's focusing on what's ahead. "We've made so much progress," she tells me in Spanish, "but the horizon is still far away."

Nilda grew up as one of eight siblings in Vega Alta on the big island; her mother spoke often about national pride. Nilda remembers being moved, as a girl, by the plight of the Viequenses, who lived amid frequent bomb explosions as if they were at war. But their "enemy" was their own country; Puerto Rico is a U.S. territory

Right: A view of the coast that had been a part of the military training ground.

and its people U.S. citizens, although they cannot vote for president or members of Congress.

In 1980, as a 35-year-old science teacher, Nilda came to Vieques to work in the schools and volunteer as an activist. "The people were in crisis," she recalls. "There had been protests years before, but they lost momentum. Hope was low." And psychological trauma was widespread, she found. "Bombs fell [on testing ranges] 20 days a month, 12 hours a day," Nilda says. "People would run to their homes, scared that bombs would fall on them. Children would cry." Amid the sounds of low-flying planes, Nilda staged small protests and used her background as a science teacher to go door-to-door educating people about the consequences of the military's actions. "I explained how the bombing was affecting their health and the environment," she says. "Our lagoons, land and ecosystems were at risk of being destroyed."

In her first year in Vieques, Nilda met her soul mate, Robert Rabin, an American college student researching his master's thesis here. They quickly became partners in love and activism and have been together ever since. In 1993, the couple helped set up the Committee for the Rescue and Development of Vieques (CRDV), a group that reenergized the protest movement against the bombing. For years they struggled to gain attention. Then, in 1999, a security guard at the weapons testing facility, David Sanes Rodriguez, was accidentally killed by two 500-ton U.S. bombs that fell too close to his post. "He was one of us," Nilda says. "After his death, the people said, 'No more.'" Nilda and others organized demonstrations, and thousands of protesters, including the actor Edward James Olmos, staged round-the-clock sit-ins. "Many of us were arrested," she recalls. Dignitaries such as Pope John Paul II and the Dalai Lama sent messages of support. In 2000, a politician named Sila Maria Calderón won the race for governor of Puerto Rico (the only woman ever elected to that office) on promises that she'd push the military to halt the bombing.

In 2001, President Bush announced that the U.S. military would pull out of Vieques two years later, saying that Puerto Ricans "are our friends and neighbors, and they don't want us there." At last, on May 1, 2003, the bombs fell silent. That silence was followed by an explosion of joy in Vieques, complete with fireworks, music and dancing in the

"Bombs fell 20 days a month, 12 hours a day," Nilda says.

Left: Visitors are warned of unexploded bombs on former testing grounds. Right: Nilda and Mariane walk by a former U.S. bombing range.

Above: Strollers sit outside the nursery at Nuestra Escuela, a school for dropouts. Right: Students (all teen moms) outside the island's only high school.

streets. "People finally understood that ours was truly a human rights struggle," Nilda says. The military pullout was a political triumph for the people and a personal triumph for Nilda, who had dedicated nearly half a lifetime to making it happen.

During the past four years, Viequenses have wondered: What's next for us? While there is reason to feel hopeful, the islanders face myriad new problems, and old ones as well. Much of the land is contaminated with toxins, experts say, and thousands of unexploded bombs remain buried under former testing grounds. Cancer is about 30 percent more common here than in the rest of Puerto Rico, according to several reports, and with one private doctor for every 9,000 residents, health care is substandard. Plus, even as foreign investors work to turn the island into a luxurious tourist haven, few locals (72 percent of whom live in poverty) have the skills or resources to benefit.

Nilda doesn't rest on her laurels; in fact, I'm not sure Nilda rests at all. Acting almost as an informal mayor, she is tirelessly working to ensure that her friends and neighbors have healthy and prosperous futures. The CRDV is lobbying the U.S. government to restore the environment—basically, to clean up the mess it made and then left behind. But Nilda's main mission is helping residents take advantage of the economic boom which, by rights, should belong mostly to them. "Natives must develop businesses

Cancer is about 30 percent more common here than in the rest of Puerto Rico, according to several reports.

or they'll always be dependent on foreign whims," she says. "Fighting the military was sexier, but this is our new social justice movement: to make sure the people benefit from the development of Vieques."

I attend a small-business seminar Nilda has organized in a museum that was once a Spanish fort; here, 12 participants are learning how to get financing and write business plans. Carmen, 21, hopes to start a catering company. Itza, 18, wants to open a community center for young mothers. "Are you a mother?" I ask. "I have three," she says. "All different daddies." Now she's settled down with a fourth man. "This one," she says, "is mature." Itza tells me that the youth of Vieques struggle because there's little for them to do. "Young people drink, do drugs and have too much depression," she says. "Boredom is getting the best of us."

The next day, Nilda takes me to the only high school in Vieques (there is no university) and introduces me to five girls, ages 15 through 17. All are single mothers. "We have no movie theater, no bookstore, no entertainment whatsoever," a girl named Claimar says. "Sex is all there is to do." I tell the girls I will turn 40 this year and have a five-year-old son. When I say I had my first boyfriend at 19, they think it's hilarious. The girls dream of becoming nurses or social workers, just as I had many kinds of dreams as a young girl in Paris. But unlike me, with my supportive mother who taught me to accept no limits, they have no idea how to make their dreams happen.

But change is coming faster these days because activists like Nilda are making the Puerto Rican government pay attention. A recent breakthrough: Vieques' first maternity ward, where 300 babies have been born. There's also a new school for dropouts, Nuestra Escuela, where I meet Adelaida, a single teen mom. "I feel respected here, for the first time in my life," says Adelaida, who was raised in foster care. I also meet Andres, who walks with crutches after being diagnosed with cancer. "I am 17; I shouldn't have cancer. But I swallow my anger," he says. Gesturing toward the other kids, he adds, "We all do."

Dinette, a young woman with copper-colored skin, is working at Nuestra Escuela to put herself through physical therapy school. We meet later, and she shows me the tiny room she rents with her boyfriend, who's 15 years older than she is. Dinette and her friends spend most of

Right: Andres, 17, was recently diagnosed with cancer, which forces him to rely on crutches.

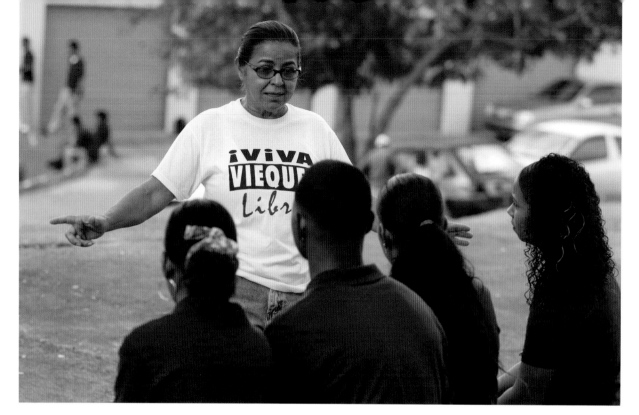

Nilda doesn't rest on her laurels; in fact, I'm not sure Nilda rests at all.

their time at a bar down the street where the bartender works in bare feet, and she takes me there. The place has a strange collection of paintings: a romantic landscape with two horses, a still life with apples, a vodka ad featuring three Josephine Baker look-alike models. Leaning against the jukebox, Dinette glances at two skinny cats fighting. "That's the way it goes here," she says. "Different day, more fighting."

Dinette and I leave for dinner, and when we drive back to the bar, several drunken boys she knows jump into my rental car; one of them is holding a steel bar. As unnerved as I am for a moment, it's clear to me that these boys are more bored than harmful; I point out that we are on a tiny island, and if they hurt us, they couldn't escape. Convinced her friends are just fooling around, Dinette leaves with them. As I drive away, I watch her reflection recede in the rearview mirror until she becomes a little dot.

The next day I take the ferry to the mainland and watch Vieques until it, too, becomes a little dot. Later, from the plane, I watch Puerto Rico, green and seemingly fragile from the air, disappear beneath the tropical clouds. I think of Dinette, the newborns, Andres and his cancer fight. I think about Vieques' best asset in its ongoing struggle: its own people, the older ones with their wisdom and experience, who held on through the bombings, and the young ones, with their innocent dreams and untapped energy. They have saved their land, and now they are working on their souls. Sometimes that second fight is harder than the first. But once again, they have Nilda on their side.

Above: Nilda talks with high school students. Right: A ferry arrives from the Puerto Rican mainland.

Afterword

A YEAR INTO THIS ADVENTURE, I FEEL A MIX of humility and joy. Humility because the women I have met are truly fighting problems that affect the lives of thousands, if not millions, worldwide. I feel humble because they are human, too, just like the rest of us, although it's easy to mistake them for superheroes. But the joy I feel runs deeper than the humility, because now I have an answer for my son, who lost his father to blind hatred: Yes, there is hope in the world, and it isn't naive or even idealistic; it is real. It is carved from the very essence of people's souls; learning this is probably the most beautiful thing he will ever experience. This hope belongs to us all; let's pass it on like an Olympic flame, from one determined individual to the next.

Arctic explorer: Mariane braces against bitter winds in Iqaluit, Canada.

If you want to help...

CAMBODIA: Somaly Mam

ACTING FOR WOMEN IN DISTRESSING SITUATIONS (AFESIP), founded by Somaly Mam, combats trafficking of women and children for sex slavery. The program cares for and rehabilitates those rescued while also teaching them occupational skills.

> AFESIP Cambodia
> Phone: 011 855 023 884 123
> www.afesip.org
> * Currently, AFESIP accepts donations only via credit card or wire transfer; please see its website for details.

CANADA: Sheila Watt-Cloutier

THE CENTER FOR INTERNATIONAL ENVIRONMENTAL LAW (CIEL) works to protect the global environment and to promote human rights and health. CIEL's climate change program aims to protect the earth's climate system in troubled regions, including the Canadian Arctic.

> CIEL
> 1350 Connecticut Avenue NW, Suite 1100
> Washington, D.C. 20036-1739
> Phone: 202-785-8700, ext. 5829
> www.ciel.org
> * Please make checks payable to Ciel/Arctic Fund. For online donations, please note "Arctic Fund" on your donation form.

COLOMBIA: Mayerly Sanchez

WORLD VISION, a Christian humanitarian organization, works with children, families and their communities worldwide to fight poverty and injustice. World Vision remains actively involved with Mayerly Sanchez and the Colombian children's peace club.

> World Vision
> P.O. Box 9716
> Federal Way, WA 98063-9716
> Phone: 888-511-6548
> www.worldvision.org/peace
> * For donations by check, please include the word "peace" on the notes line.

HONG KONG: Anson Chan

HONG KONG COMMITTEE FOR UNICEF (HKCU), founded in 1986, organizes fund-raising and advocacy programs in order to finance and assist UNICEF's projects in that region. Anson Chan is the vice chairman for the HKCU council.

> Hong Kong Committee for UNICEF
> 3/F, 60 Blue Pool Road, Attn.: Fund-raising Department
> Happy Valley, Hong Kong
> Phone: 011 852 2833 6139
> www.unicef.org.hk
> * For donations by check, please make out to Hong Kong Committee for UNICEF.

LIBERIA: Ellen Johnson Sirleaf

THE LIBERIAN EDUCATION TRUST (LET) supports the restoration of basic education in post–civil war Liberia: building schools, training teachers, awarding scholarships (principally to girls), supporting teacher training colleges and enrolling market women in literacy programs.

> Liberian Education Trust
> c/o Phelps Stokes Fund
> 1400 Eye Street NW, Suite 750
> Washington, D.C. 20005
> Phone: 202-371-9544
> www.liberianeducationtrust.org
> * For donations by check, please make out to Phelps Stokes Fund and write "liberian education trust" on the notes line.

MEXICO: Lydia Cacho

CIAMCANCUN, founded by Lydia Cacho, is committed to providing shelter, safety and advocacy for victims of battering, sexual violence and trafficking of women and girls in the Cancún region.

> Ciamcancun
> Calle Mero #26 Smza 3
> Cancún Q.roo 77500
> Mexico
> Phone: 011 52 998 898 0755
> www.ciamcancun.org

Go to glamour.com/globaldiary for updates.

Acknowledgments

NEW YORK: Dr. Angela Diaz

THE MOUNT SINAI ADOLESCENT HEALTH CENTER is the largest provider of outpatient adolescent health services in the U.S., offering free, confidential and comprehensive health care each year to 10,000 underserved kids, ages 10 to 21. Angela Diaz is the center's director.

> Mount Sinai Adolescent Health Center
> 320 E. 94th St., 2nd Floor
> New York, NY 10128
> Attn.: Angela Diaz, MD, MPH
> Phone: 212-423-2900
> www.mountsinai.org/ahc

UGANDA: Dr. Julian Atim

PHYSICIANS FOR HUMAN RIGHTS (PHR) mobilizes the health professions to advance the health and dignity of all people by protecting human rights. The organization's Health Action AIDS campaign encourages health professionals, such as Dr. Atim, to support a comprehensive AIDS strategy and advocates for funds to combat the disease.

> Physicians for Human Rights
> Development Office
> 2 Arrow St., Suite 301
> Cambridge, MA 02138
> Phone: 617-301-4200
> www.physiciansforhumanrights.org/julianatim

CUBA: Ladies in White; MOROCCO: Aicha Ech-Chenna; FRANCE: Fatima Elayoubi; PUERTO RICO: Nilda Medina

AMNESTY INTERNATIONAL, a worldwide grassroots movement of more than two million people, works to defend the basic human rights of people everywhere.

> Amnesty International USA
> Attn: Artists Relations/"In Search of Hope"
> 5 Penn Plaza
> New York, NY 10001-1810
> Phone: 800-792-6637
> www.amnestyusa.org

This book would not have been possible without the following people: *Glamour* articles editor Abigail Pesta, who conceived of and nurtured *Glamour*'s first Global Diary columns; *Glamour* articles editor Geraldine Sealey, who helped shape this inspiring book; designer Patricia Fabricant, who brought each of the women's stories to life with her elegant designs; Laurie Sprague, who managed every aspect of this book project; *Glamour* associate publisher Leslie Russo, who believed in the book and got the ball rolling; and *Glamour* executive managing editor Susan Goodall, who lent her expertise each step of the way.

Glamour would also like to thank: Jill Herzig, Stacey DeLorenzo, Ellen Kampinsky, Shirley Velasquez, Rebecca Webber, Sally Dorst, Peter Hemmel, Paul Kramer, Mari Gill, Elise Marton, Christine Belgiorno, Joanna Muenz, Stéphanie Augusseau, Valery Sorokin, Troy Dunham, Jasher Brea and Craig Cohen.

We are, of course, indebted to the photographers who contributed to this book: Jennifer Macfarlane, Norman Jean Roy, Jorge Rey/Getty Images, Sara Terry/Polaris, Adriana Zehbrauskas/Polaris, Simon Wheatley/Magnum Photos, Gilles Peress, Chien-Min Chung/Getty Images, Benoit Aquin/Polaris, Evelyn Hockstein/Polaris, Tara Todras-Whitehill, David Rochkind/Polaris, Jose Jimenez-Tirado/Polaris

FRONT COVER: Evelyn Hockstein/Polaris
BACK COVER: Chien-Min Chung/Getty Images
PAGE 1: Jennifer Macfarlane
CONTENTS: Illustration by troyboydesign.com
PREFACE: Sara Terry/Polaris
FOREWORD: Left, Jennifer Macfarlane; right, Marvi Lacar/Exclusive by Getty Images
INTRODUCTION: Page 12, Chien-Min Chung/Getty Images; Page 14, right: Bruno Garcin-Gasser; Page 16, top: Evelyn Hockstein/Polaris; bottom: Benoit Aquin/Polaris; Page 17, Chien-Min Chung/Getty Images
AFTERWORD: Benoit Aquin/Polaris
OTHER PHOTO CREDITS: Pages 49, 57, Mariane Pearl; Page 99, Vincent Yu/AP Photo; Page 104, Kin Cheung/AP Photo
STILLS: Pages 13, 35, 109, 135, Dominique Maitre; Page 73, Pascal Deloche/Godong/Corbis; Page 85, Lawrence Muenz
ENDPAPERS: Collages by Ariana Barry

Published in the United States by powerHouse Books,
a division of powerHouse Cultural Entertainment, Inc.
37 Main Street, New York, NY 11201-1021
telephone 212-604-9074, fax 212-366-5247
e-mail: insearchofhope@powerHouseBooks.com
website: www.powerHouseBooks.com

First edition, 2007

Library of Congress Control Number: 2007934410

Hardcover ISBN 978-1-57687-422-6

Printing and binding by Midas Printing, Inc., Hong Kong
Book design by Patricia Fabricant

A complete catalog of powerHouse Books and Limited Editions is available upon request;
please call, write or visit our website.

10 9 8 7 6 5 4 3 2 1

Printed and bound in Hong Kong

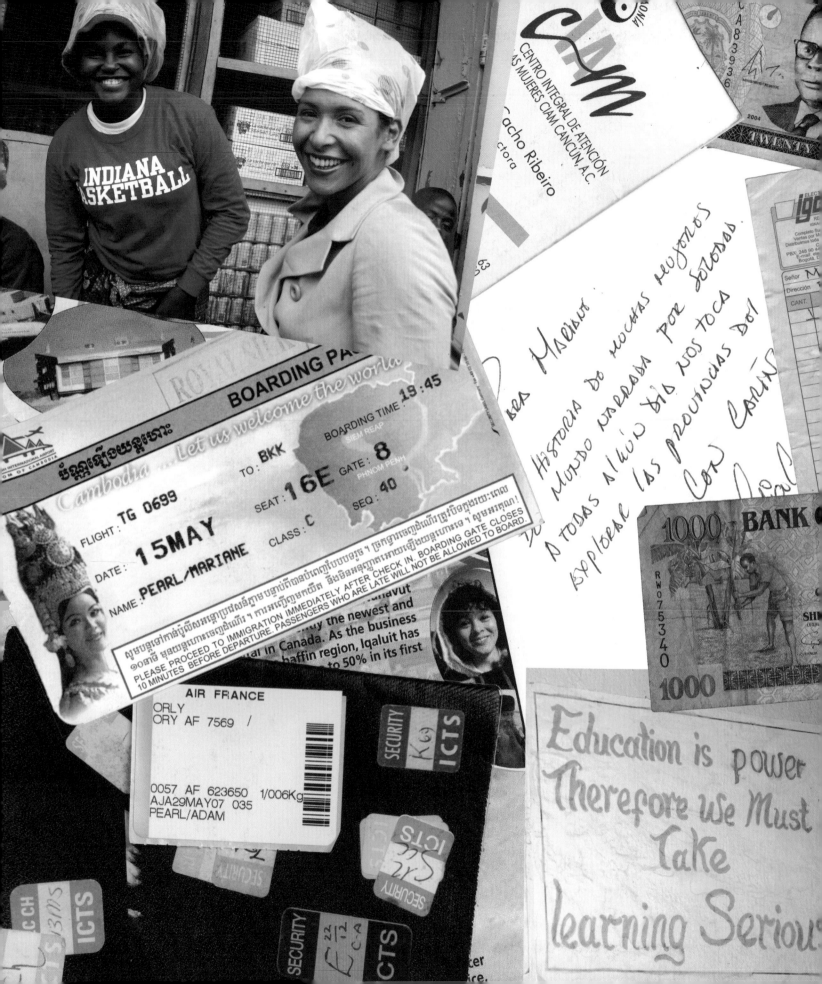